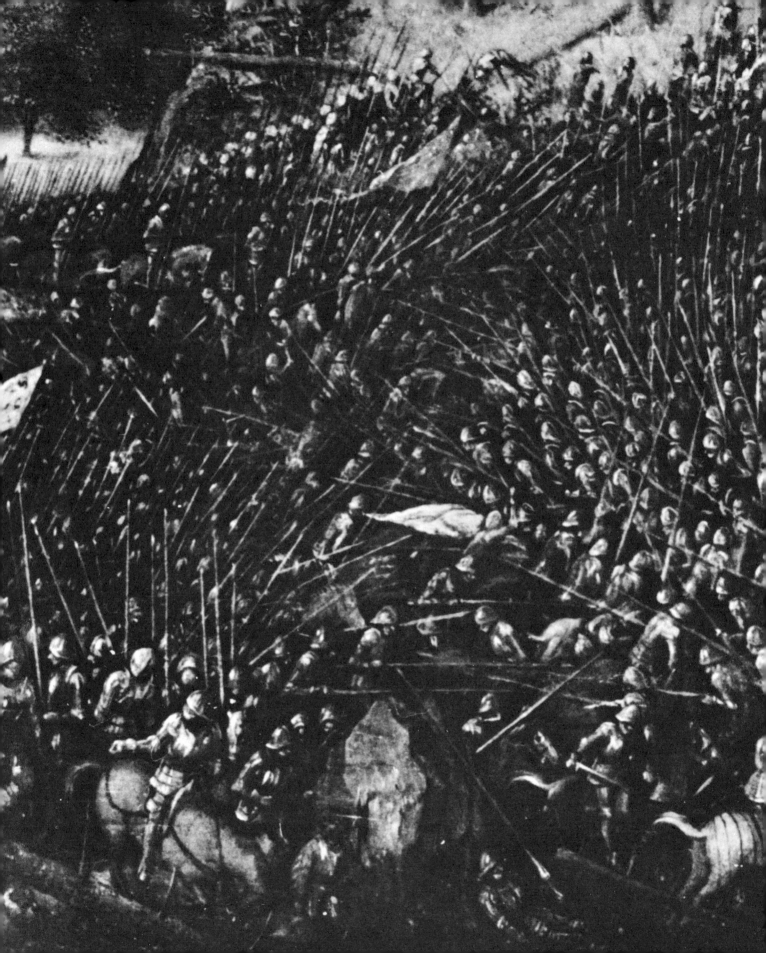

# WAR

Art and Society One ✳ **WAR** ✳ Ken Baynes

Boston Book and Art publisher

Boston Massachusetts

First edition 1970

Boston Book and Art, publisher
655 Boylston Street, Boston, Massachusetts
Library of Congress Catalog Card Number: 78–129443
SBN: 8435–0009–3
Book designed by Ken Baynes ARCA ASIA and Steve Storr
Made and printed in Great Britain by Lund Humphries,
Bradford and London

This series owes its existence to Gordon Redfern's initial suggestion and
the subsequent enthusiasm of the Welsh Arts Council and Lund Humphries.
Peter Jones, the Welsh Arts Council's Assistant Director for Art, really
deserves the title of joint author – without his day-to-day help in
developing the physical and intellectual structure of the original exhibition,
nothing would have been possible. At Lund Humphries, John Taylor has
played a similarly important role.

A book like WAR depends on the generosity of individuals, companies and
institutions who own rare and important material. All of us involved are
grateful to those who have so generously contributed in this way. They are
credited in the caption to each illustration. Particular thanks are due to
Dr Noble Frankland and his staff at the Imperial War Museum who
allowed us to draw freely on the museum's unique collection.

In my own office Mrs L A Baynes, my assistant Steve Storr and
Mrs Anne Porter put in a tremendous amount of work. In Wales many
people helped, but Miss Francine Allen deserves a special mention because
she had the onerous task of gathering together the material that we had
chosen. Alan Robinson, a colleague at Hornsey College of Art, was
responsible for research into the film material.

Ken Baynes
Battersea 1970

**Cover**
Detail of
GERMAN IMPERIAL FLAG
First World War period
(Imperial War Museum)
The complete image is shown on the title page

**Inside front cover**
Detail of painting:
THE SUICIDE OF SAUL
by Pieter Bruegel
1562
(Kunsthistorisches Museum, Vienna)

**1** Opposite
Trench knife:
WELSH DAGGER carried by raiding parties of the
9th Battalion, Royal Welch Fusiliers. Copied from
weapons used by ancient Welsh tribes and provided
by Lord Howard de Walden
(Imperial War Museum: photograph by
Brian Gardiner)

Acknowledgements
The extracts from the Penguin Dictionary, compiled
by G N Garmonsway, are reproduced by permission
of Penguin Books Ltd.
The extract on page 80 is taken from Catch 22 by
Joseph Heller published by Jonathan Cape Ltd.
The poem on page 94 by Siegfried Sassoon is
reproduced by kind permission of Mr G T Sassoon.

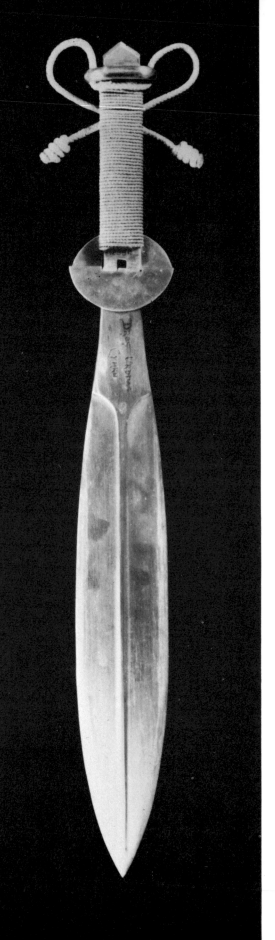

# FOREWORD

The origin of this series of books about the relationship between art and society is to be found in the dissatisfaction felt by the Welsh Arts Council for the traditional kind of art exhibition. Over a number of years the Council has developed an approach to art and design which implies that they can no longer be contained within the meaning of labels like painting or sculpture or craftsmanship. Film, photography and television have found a natural place: so have magazines, advertising, toys, the work of amateurs, seaside souvenirs and a thousand other objects, humble and vulgar as well as grand and noble. A stage has been reached when the Council recognizes that the human phenomenon known as art has countless forms, and arises from equally varied impulses.

Complementary to this acknowledgement of the tremendous variety of art and design, has been a growing interest in the uses to which they are put by society. Here the Council has found itself agreeing with the Dadaist Marcel Duchamp who said, '. . . The onlooker is as important as the artist. In spite of what the artist thinks he is doing, something stays on that is completely independent of what he intended, and that something is grabbed by society – if he's lucky . . . The work of art is always based on these two poles of the maker and the onlooker, and the spark that comes from this bi-polar action gives birth to something, like electricity.' The meaning and nature of this interaction has been little explored by critics, sociologists or psychologists, but it is the key to an understanding of the relationship between art and life.

In 1968 Gordon Redfern, the architect of Cwmbran New Town, suggested that the Welsh Arts Council should organize a series of exhibitions, based on these ideas, and each with

a single word title '. . . to try to explain the relationship between art and life – with a series of exhibitions concerned with the things in which people have intense and well known interest — War, Work, Worship, Sex, Food, — and combining numerous art forms.' The Council accepted the suggestion and commissioned Ken Baynes to organize the exhibitions. WAR opened at Swansea in February 1969 and broke every attendance record at the Glynn Vivian Art Gallery. Shortly afterwards arrangements were made for the publication of the present series of books: WAR and WORK appearing simultaneously with the opening of the WORK exhibition at the National Museum of Wales in 1970.

Taken individually, each volume sets out to be a coherent exploration of its chosen theme. Taken together, the aim of the series is more ambitious. It tries to show how art reflects, interprets and supports man's concept of himself and the significance of his role in the world. It is intended as a contribution to an understanding of art as a social activity rather than as a solely aesthetic or expressive one. The aim is to present a picture of art which avoids the 'series of masterpieces' interpretation of traditional criticism, but which concentrates instead on art as an integral part of the mechanism of individual and social existence.

# CONTENTS

**4 Poster**
DIE KUNST IM KRIEGE
German poster for an *Art in War* exhibition
First World War
(Imperial War Museum)

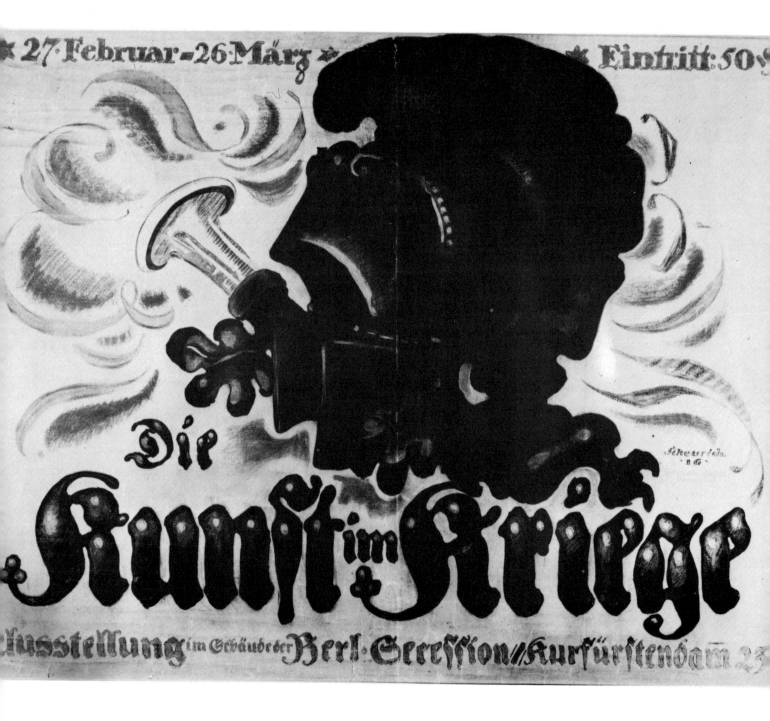

# ART AND SOCIETY

In the series of books of which WAR is the first, an attempt will be made to explore the relationship between art and a variety of other major areas of human activity. Each book will take a single fundamental theme and show how it has been expressed in art now and in the past. At the simplest level this is an effective way of bringing together work which covers a variety of human attitudes and responses, but there is more to it than that. The approach makes possible an unusually clear view of the social function of art.

**It is easy enough to see that art plays a role in society, but much more difficult to suggest a convincing theory to explain what the role is and how it works. The motives which make artists create might seem a good yardstick, but they are confused and contradictory and have varied widely from place to place. And, as Marcel Duchamp saw so clearly, there is often a big difference between what an artist is trying to do and what society takes from the results of his activity.**

Another problem is the narrowness of the area covered by traditional criticism and art history. In Western Europe and America discussion has concentrated on the importance of a few exceptional individuals – 'great masters' in the Renaissance mould. This approach gives a very lopsided view of art, cutting off all the more humble and everyday ways in which imagery is applied to life. To make any kind of sense of art as a social phenomenon, it is necessary to interpret it far more widely so as to include this other vast output, hand- and mass-produced.

**The material gathered in the world's great museums is only the top of a colossal iceberg, the base of which stretches away below the surface of the limited range of attitudes and**

# Nice Lines of Communication

activities that are thought of as 'cultural'. Only when the base as well as the top of the structure is included does it become clear that people's response to life, even their actual experience of it, has always been in all manner of ways determined, described, interpreted and enlarged by art.

In total these complex interactions represent the social function of art. To try, as these books try, to make possible an assessment of that function is a formidable undertaking. As has already been suggested, the method adopted is to arrange and present a very wide range of material. This seems a more realistic approach than attempting to put forward any final conclusions. Nearly always the material speaks for itself, demonstrating the extraordinary way in which questions of style and aesthetics are at every point involved in mankind's most basic needs, hopes, dreams and fears.

Yet there are questions which must be answered, or at any rate discussed. For example, what has been the effect, on

**5** Left
Strip cartoon:
NICE LINES OF COMMUNICATION
by Milton Caniff
from *Male Call*
(Copyright 1968 by Milton Caniff, New York)

**6** Below
Ceramic:
BRUCE BAIRNSFATHER'S OLD BILL
(Imperial War Museum: photograph by
Brian Gardiner)

the role of art, of the industrial revolution and its
associated upheavals? How has technology changed art
through printing, photography, cinema and television?
What relevance have traditional forms of criticism to the
social function of art? How does art support or defy
public morality? How are forms of art used by society to
foster ends it considers good? Can art be genuinely
subversive – has it any political role? What relation to the
effectiveness of communication have aesthetic principles
like harmony and proportion? What kinds of standards are
significant in assessing art's social function – is it
appropriate to consider standards at all? And so on. The
social role of art is so far relatively unexplored.

Each book in the series will look at its subject principally
through the discussion of one key question – the significance
of aesthetic styles in this volume, the impact of social change
in WORK, art's relation to ritual and belief in WORSHIP.
But each will also reflect on all the questions just

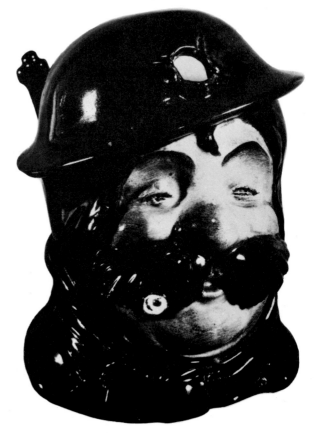

posed and, centrally and essentially, on the tremendous aesthetic, ethical, economic, and social changes that have taken place as a result of the industrial revolution.

So, although each book does give a broad picture of its chosen theme, it would be a mistake to think of the series as simply containing illustrations or historical documents. The real subject matter is art, and the nature of its involvement with society.

This perspective is completely different from that normally found in books on art or in books on social history. The material shown does not make possible the discussion of a group of artists, nor does it follow the development of a school or an individual. It does not even allow for an historically accurate understanding of art at a particular time and place. Equally it does not make possible an exhaustive social discussion of its subject. The present book is not a social history of war. The material is chosen for another reason – its ability to show the nature of art's relationship with the people who made it and with the people who used it or looked at it. To show its place in their lives and, by generalization, its place in society.

To take an example. The illustration opposite shows a testimonial given to Major Roberts by the relatives of his soldiers after the First World War. It is in Welsh and the scene of lakes and mountains is near Pen-y-Groes, the major's home. The testimonial is a fine object by any standards, but it would certainly not find a place in any normal discussion of art in the twentieth century, and probably not in a book on modern lettering and illumination. It is not significant in the history of art because it is extremely – and intentionally – traditional. It is not even, in the ordinary sense, folk art. All these factors, however, argue for its inclusion here. Its quality of being traditional, of being the extension of an activity a thousand years old, was undoubtedly a part of its meaning to a man returning at last to normal life after taking part in a long and dreadful war. Its style spoke of security and continuity. Its obvious dignity and seriousness must have meant a great deal to those who had the idea of having it made and then gave it as a token of their gratitude.

7 Testimonial
AN EXPRESSION OF GRATITUDE GIVEN TO MAJOR ROBERTS
by C W Norris
(Katherine Shelton Jones)

The text of the testimonial reads:

To the Major John Hamlet Shelton Roberts Gwyddfor, Pen-y-Groes on Saint David's Day 1919.

Be it pleasing to you to accept this tribute, together with a watch and gold chain as a small token of the love and deep, sincere admiration which is felt towards you by the people of the Vale of Nantlle for your personal amiability, and especially for the kindness and gentle, endless care which you showed throughout the Great War towards our soldiers under your authority and leadership. This kindness, care and generosity has made your name dear and respected wherever it is heard; and it would be easily believed that there was not in the whole army an officer more loved than you by those with you in the bloody battle of Gallipoli, Egypt and Palestine.

We congratulate you on the success and glory which followed your feats on the battlefield; and we rejoice that your courage is now recognized by your promotion to Major, and especially we thank God for sparing you from all danger and giving us the sincere pleasure of welcoming you back to your old neighbourhood.

We are concerned that your dear home was burned down while you were away in battle, but it is the heartfelt wish of your neighbours that you will build a new hearth on Hen Lannerch, and enjoy several happy years among people who bless you for the gentleness of your character and the graciousness of your many deeds.

I'R
UCH-GAPTEN

John Hamlet Shelton Roberts,

GWYDDFOR, PEN-Y-GROES,
ar Ddydd Gwyl Dewi 1919.

Boed gwiw gennych dderbyn hyn o ANERCHIAD,
ynghyd a'r
ORIAWR A'R GADWYN AUR,

yn arwydd fach o'r serch a'r edmygedd dwfn a diledryw a deimlir tuag atoch gan drigolion Dyffryn Nantlle a'r Cylch oblegid eich hawddgarwch personol, ac yn arbennig oblegid y caredigrwydd a'r gofal tyner a di ben draw a ddangosasoch ar hyd y Rhyfel Mawr at ein Milwyr oedd dan eich awdurdod a'ch arweiniad. A mae'r caredigrwydd a'r gofal a'r haelioni hwn wedi gwneuthur eich enw'n un annwyl a phercaroglus lle bynnag ei clywir; a rhwydd y credwn nad oedd yn yr holl Fyddin yr un Swyddog a gerid yn fwy nag y cerid chwi gan y rhai fu gyda chwi yn ymdyro gwaedlyd Gallipoli, Yr Aifft a Gwlad Canaan.

Llongyfarchwn chwi ar y llwydd a'r clod a ddilynodd eich gorchestion ar faes y gad; llawenhawn ddarfod cydnabod eich gwrhydri drwy eich dyrchafu yn Uch-Gapten; ac yn anad dim, diolchwn i Dduw am eich gwaredu o'ch holl beryglon, a rhoddi inni'r hyfrydwch diffuant o gael eich croesawu'n ol i'ch hen gynefin.

Tosddiwn oblegid i'ch cartref eu lynd eu llosg a chwi draw yn y drin; ond dymuniad calon pob un o'ch cymdogion ydyw eich gweled yn codi Aelwyd Newydd ar yr Hen Lannerch, ac yn cael mwynhau llawer blwyddyn bur o wynfyd ynghanol pobl sy'n eich bendigo am fwynder eich cymeriad a graslonrwydd eich llu gweithredoedd.

W. J. Griffith        Cadeirydd        R. H. Jones.        Cesglydd

Richard Jones.        Isgadeirydd        W. W. Thomas.

O. W. Owen        Trysorydd        William Parry        Dysgkennydd

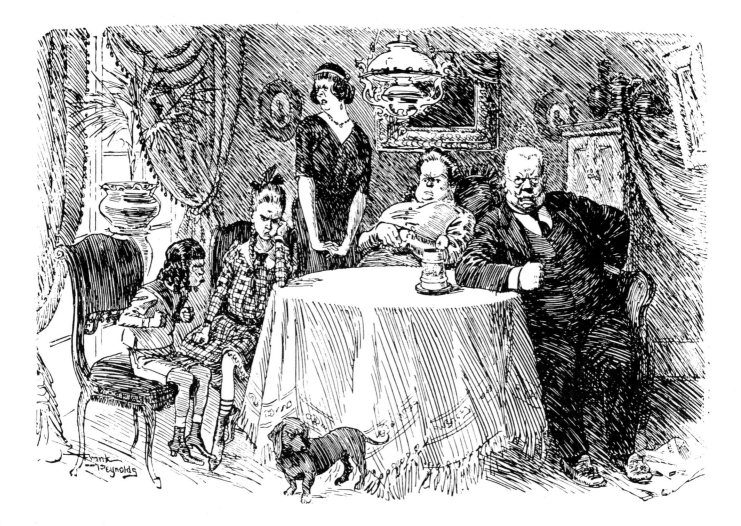

The testimonial stood at the focus of a network of human
emotions and relationships. It was a symbol. The relationship
between Major Roberts and his soldiers was made tangible
in an object so that it could be felt and seen, admired and
remembered. In this the testimonial is characteristic of a
whole class of objects in which men try to preserve the truth
of their experiences in materials more durable than the
experiences themselves or the memory of them.

Another example. The cartoon by Frank Reynolds shows
A PRUSSIAN HOUSEHOLD HAVING ITS MORNING
HATE. Again, this is a good drawing that has no special
place in the history of art or the cartoon. But it is a
fascinating representation of 'the enemy'. It is a little hard
now to reconstruct the exact meaning that the drawing
would have had when, during the first world war, it
appeared in *Punch*. Was it to be taken seriously?

8 Cartoon:
STUDY OF A PRUSSIAN HOUSEHOLD HAVING
ITS MORNING HATE
by Frank Reynolds
First World War
(Reproduced by permission of *Punch*)

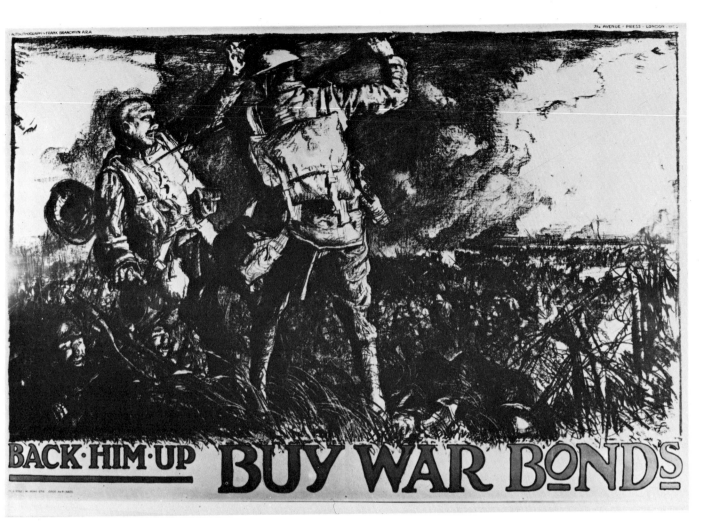

BACK·HIM·UP BUY WAR BONDS

Presumably not, though many straight-faced contemporary representations of Germans as stage villains now seem absurd to us. More likely it was funny. Who could not take on and beat these grotesques? Grandpa and grandma like balloons waiting to pop, mother a genteel gargoyle, the children and the sausage dog caught up in it all.

Laughing at the idiocy of foreigners has an ancestry of great length but, in wartime, it has extra significance and seems to well up spontaneously in an outburst of xenophobia. The art of invective drenches a society at war, creating something like a temporary mass myth of the enemy's combined beastliness and incompetence. All this the Reynolds cartoon perfectly exemplifies, making clear a particular aspect of art's involvement in the effort to sustain national morale and self-consciousness at a time of crisis.

9 Poster:
BACK HIM UP BUY WAR BONDS
by Frank Brangwyn
First World War
(Imperial War Museum)

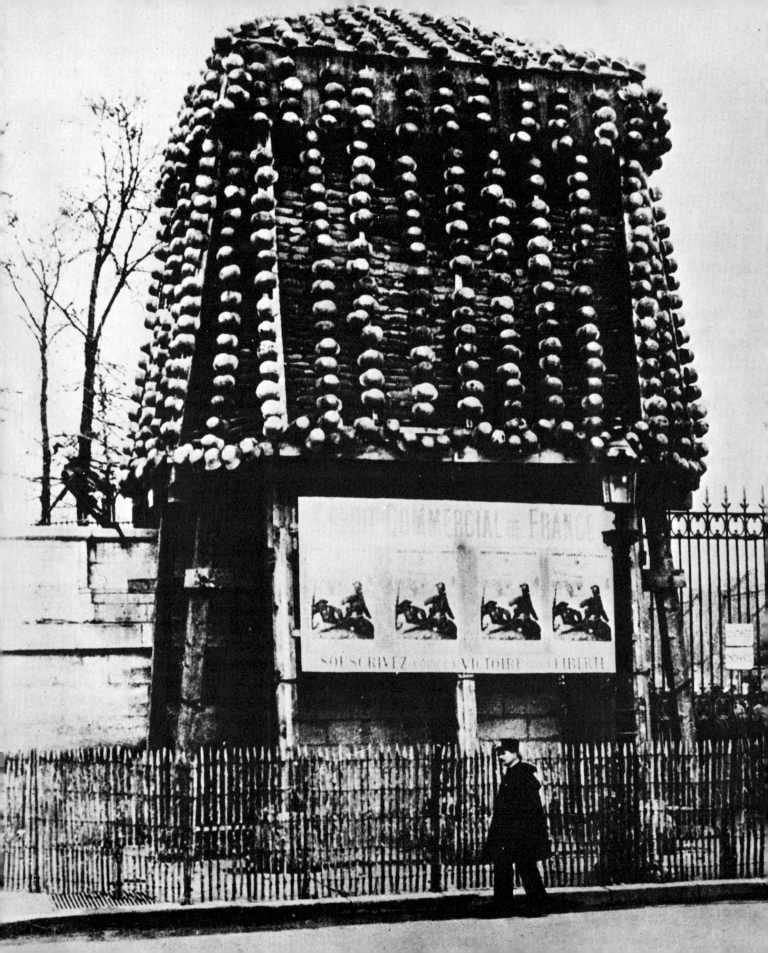

**10** Left
Photograph:
IDOL
from *The First World War – A Photographic History*
(Daily Express Publications, 1933)

**11** Below right
DINNER PLATE
showing the progress of a German tank campaign
(Imperial War Museum: photograph by
Brian Gardiner)

In short, the whole emphasis of these books is away from a discussion of art *solely* in terms of aesthetics or expression. Instead those two qualities are seen as part of a much bigger whole in which can be recognized art's uses. Although art is not normally thought of as 'useful', it has, in fact, an immense range of application to ritual, status, myth, science and entertainment. This is what the books set out to explore.

It is worth asking whether there is any particular reason why we should now be so interested in art as a social phenomenon. There is no doubt that, in part, it is simply because the approach is of a piece with the scientific and pragmatic methods of enquiry that are characteristic of the twentieth century. It is the logical extension of our knowledge about the psychology of artists, the existence of which represents a turning point in art criticism, and is closely linked with the development of art movements like Surrealism and Dadaism.

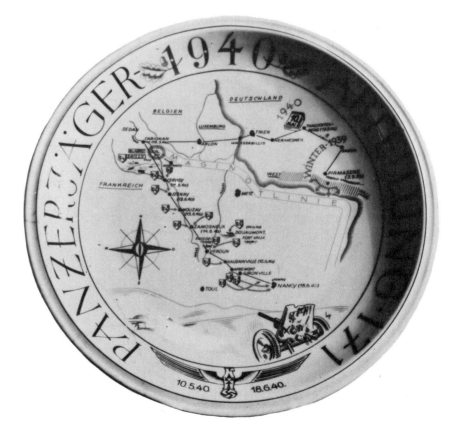

But there is another aspect which is of even greater importance. It is that, more than ever before, we *need* to understand the significance of art in people's lives – including our own.

Since the industrial revolution the centre of gravity in society has changed decisively, and the centuries-old formula of a hierarchical world has been shattered for good, replaced by egalitarian ideals expressed in a variety of ways. The machine's involvement in culture, and the world of big cities that Victorian technology made possible, are completely new elements in men's lives. Any selection of art, drawing examples from the immediate past and comparing them with the work of the Renaissance or the Middle Ages or the art of, say, ancient Iran, will show these changes as living realities.

Not only has the balance of society changed: equally decisive has been the linked change in the role of art. As a direct result of technological innovation culture is now mass culture with all the confusion of traditional values and thought that that implies.

**Today, with the development of mass media such as magazines, film, television and advertising, the world is more than ever before being understood and perceived through man-made images, sounds and gestures. The meaning of climactic events like love and death and adventure are now interpreted through entertainment as much as through direct experience, religion or politics.**

The dead on both sides in Vietnam – efficiently slaughtered by technology – have told their tales at firesides wherever the invention of television has carried them. That paradox, and what it means, that mixing of news and entertainment, morality and sensation, is a key one for the contemporary world and the quality of our lives in it.

12 Below
Detail of German Helmet:
IMPERIAL EAGLE
First World War Period
(Imperial War Museum: photograph by Julian Sheppard)

13 Right
Film still:
from BEACH RED
Cornel Wilde
(National Film Archive)

# STYLE AND COMMUNICATION

**14** Transfers:
SELECTION OF MODEL AIRCRAFT TRANSFERS
(Airfix Ltd: photograph by Brian Gardiner)

**15** Film still:
from TRIUMPH OF THE WILL
Leni Reifensthal
(National Film Archive)

At first sight it might seem perverse to start a series of books devoted to the relationship between art and life with a volume about war. Behind the plumes and uniforms, the arrogant insignia and brave flags, is that ubiquitous symbol of waste – a slaughtered man. But it is a good place to begin because, as with pornography, the imperative which art serves in war is strong enough to shatter easy assumptions and reassuring clichés. The material involved inevitably makes short work of such simple notions as 'beauty equals good', 'beauty equals truth' and even 'art equals beauty'.

The moment criticism ceases to concentrate on masterpieces and instead sees these as a part of something larger, art takes on a less grandiose aspect. In looking at the 'humble and everyday ways in which imagery is applied to life' it becomes clear that art is involved in every side of men's activities, positive and negative. It is as truthful as men are truthful: as cynical as men are cynical: as frightened or as brave.

**Art is no less involved in a Nazi banner than in a pacifist poster. In purely aesthetic terms, a Nazi banner may even be stronger and more dramatic, a visual symbol of great intensity. The emotions that men feel for and against insignia – the cross, the hammer and sickle, the plough and the stars – are specially potent in the link between art and war, but they also characterize in a general sense the functional link between art and society.**

Art is not detached from life. Yet it maintains its own identity. It works – can only work – through the ingredients of its own visual language and the historical precedents that it has set and that have become accepted. This operates

at a number of levels. In patriotic posters there is one kind of gesture; in pin-ups another. Innovation crystallizes and becomes a genre. Popular imagery is made up of thousands of these limited areas where communication is carried on through the stereotypes of a particular form. Thus the visual language of the regimental badge is totally different from the visual language of the political cartoon, and this difference is an essential part of the possibility of communication. The distinctiveness of each form gives the viewer a frame of reference, a visual clue about how the message is to be read.

The link between stereotypes and communication brings us face to face with the contradictory nature of all art and design, whether it is Uccello's ROUT OF SAN ROMANO or a *Punch* cartoon. A *Punch* cartoon is a *Punch* cartoon before it is anything else. The ROUT OF SAN ROMANO is a painting before it is anything else. We can propose it as a rule that a painter wants to paint because he is obsessed by art, not only because he is inspired by events in life. That a film maker is obsessed by films, not only by social purpose or the simple desire to communicate. Similarly with a writer – it is other writing which is normally the starting point for his work. The role of art in the life of an artist must be different from the role of art in the life of society. It is important to understand this because it affects what art can say and how it says it.

For example, the work of Paul Nash, who painted pictures in both world wars, demonstrates the way in which an artist will search out images to fit his own vision. As Nash's work was normally lyrical, built on a pantheistic feeling for the movement of the seasons in the English countryside, his war paintings are often quite peaceful. It is interesting to compare his famous picture of first world war desolation, WE ARE MAKING A NEW WORLD, with photographs of actual conditions at the front. In spite of the unearthly red cloud and the fungus-like mounds in the foreground, there is a feeling of order which depends on the painting's composition and structure. This orderliness is completely missing from the mindless chaos depicted in the photographs, and seems to come from Nash's own sensibility. It is probably the only way in which he could come to terms with the subject as an artist. In the second world war he painted the beautiful aircraft trails in the sky over south-east

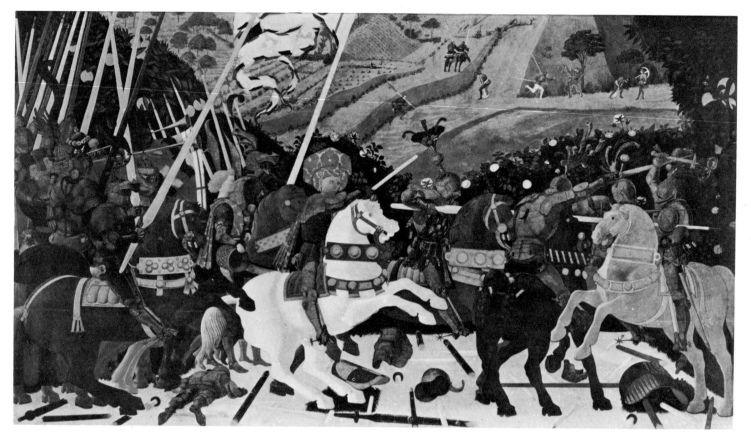

**17** Painting:
THE ROUT OF SAN ROMANO
by Paolo Uccello
(The National Gallery)

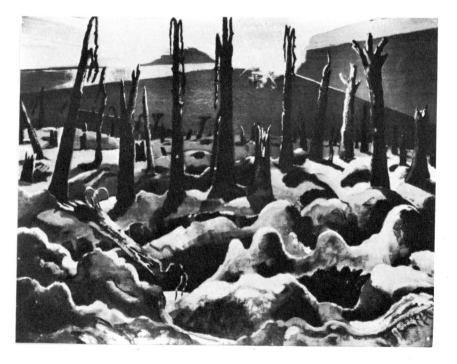

**18** Painting:
WE ARE MAKING A NEW WORLD
by Paul Nash
First World War
(Imperial War Museum)

19 Etching:
from THE DISASTERS OF WAR
by Goya
(British Museum)

England and – an extremely effective picture – the hulks of destroyed German aircraft dumped in a pattern recalling the waves rolling onto a deserted beach.

In a recent television broadcast Henry Moore described the moment of recognition which was the beginning of his great series of shelter drawings, showing people sleeping in the Underground during the second world war. What he saw were tunnels full of 'his' reclining figures. Again, the event fitted in with what was a lifelong obsession.

But it is Goya who shows, most dramatically, the tremendous complexity of the interaction between art, everyday life, and the world of the imagination. Perhaps no other artist interprets so compellingly the enormity of the heroic illusion about war or shows so decisively its foundation in mindless terror and negation. However, it does not make sense to suppose that Goya's great etchings on THE DISASTERS OF WAR originated solely, or even mainly, from his experiences. There is in them a complicated tension between antecedents in art, the techniques of etching, actual events, Goya's own horror of war, and the phantasmagoria of his imagination. If the depths had not already been there inside Goya, it is unlikely that he could have interpreted them in the way he did. André Malraux makes this clear in his book on Goya:[1]

Again, there is here no more a reporting of war than before there had been a reporting of sorcery. The element 'from life', in the DISASTERS, as in the CAPRICHOS, is indeed slight . . . Like all artists Goya eagerly probed reality for what he needed; a gesture, a kind of lighting, very often an expression, by isolating them from their surroundings and by introducing them into his dream, the dream to which they had given shape.

At the same time, his work did come from the upheavals of his day, and had bitter relevance for them. Malraux also writes:

Is it often given to an artist to embody his age-long obsessions in the suffering of a people? His art, till then incurably solitary, suddenly embodied the brotherhood of Spain . . . The DISASTERS take on their full meaning when we realize that they are not only the work of a bitter

[1] André Malraux: *Saturn, an Essay on Goya.* Published in Britain in a translation by C W Chilton by Phaidon Press Ltd, 1957.

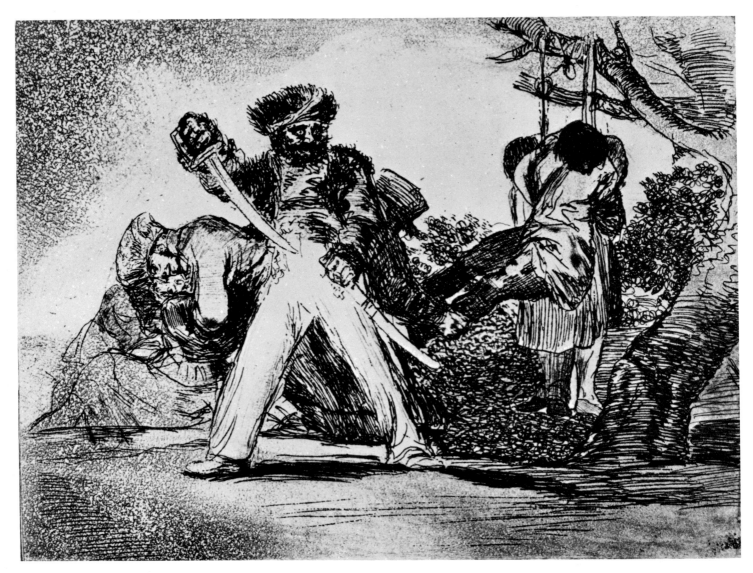

**20** Etching:
from THE DISASTERS OF WAR
by Goya
(British Museum)

patriot but also of a deceived friend, [they are like] the sketch-book of a communist after the occupation of his country by Russian troops.[2]

So we too, living 160 years later, recognize the meaning of Goya, and see that his work illuminates our own crisis, our own black night:

His genius sprang from other sources; from the dialogue that has gone on, ever since the songs of Sumeria, between the closed lips of a tortured child and the face, for ages past invisible – and perhaps inexorable – of God. He [Goya] also bears witness, on the other side. An endless procession of misery moves forward from the depth of ages towards these figures of horror and accompanies their torments with its subterranean chorus.

**With rage Goya asks 'Why?' It is a question at once metaphysical and psychological, reaching beyond the fact of war into the meaning of suffering and the meaning of life. The question, and the visual form which Goya found for it, are as vivid now as they ever were. But, because Goya was an artist, it is impossible to wrench his work completely free from the context of art. Malraux ends his book with these words: 'And now modern painting begins'.**

It seems a long journey from the stereotypes of popular imagery discussed at the start of this chapter to the density of meaning and response to be found in Goya. But the continuum is real in that Goya has left the mark of his visions on films, photographs, posters, and television programmes as well as on modern painting. And, although he was a colossal figure, his vision itself came in part from less impressive painters like Magnasco and from the demons and spirits crouching in the background of the popular imagination of Western Europe. The continuum is a concern with evil as a tangible thing, and the visual language associated with it is consistently black and claustrophobic, savage and atmospheric.

Looked at in this way, the popular stereotypes are simply small-scale examples of a larger phenomenon – the association between particular visual styles and particular meanings.

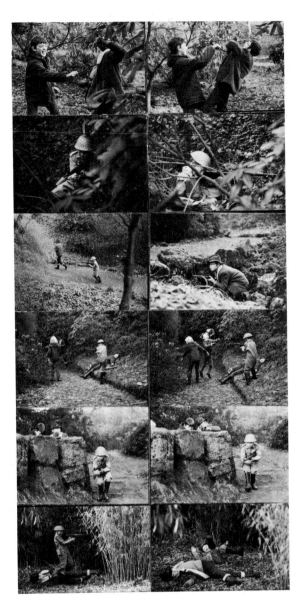

**21** Photographs:
CHILDREN PLAYING NEAR CARDIFF
Specially photographed for the book
by Julian Sheppard

[2] The words in brackets are an addition to make sense of the passage when taken out of context. Malraux is speaking figuratively, referring to the situation in Spain in 1808. His book was published in Britain one year after the crushing of the Hungarian uprising. This part of the WAR book was written five days before the Russians invaded Czechoslovakia.

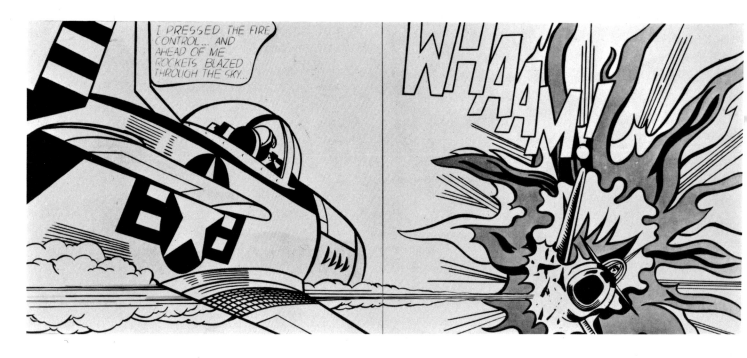

Even when art comes up against events as cataclysmic as those in war the relationship between meaning and style seems to hold good. The internal 'rules' of art remain constant as part of the medium of communication. If we take a word like Romanticism, it is easy to trace the exotic, passionate, glamorous and improbable elements provided by the dictionary definition. They crop up in such diverse places as Delacroix's MASSACRE AT SCIO, Roy Lichtenstein's WHAM and Barbarella's science-fiction struggles with the Black Queen. If we take Realism, it is possible to trace the 'ability or willingness to face facts; absence of illusion or theorizings; attempt to describe . . . some fact as it actually is' from Bruegel through to the work of the best war photographers in Vietnam. In the same way, Goya's work stands at the apex of Expressionism.

**It is with this link between style and communication in relation to war that the major part of the present book is concerned. The next six chapters look in turn at the visual language of Classicism, Romanticism, Realism, Symbolism, Expressionism and Escapism. Each chapter consists primarily of a group of illustrations. Some of the illustrations fit the stylistic keyword very closely indeed, others less so – some could no doubt fit into more than one category. But the consistency within the divisions is vivid: the meaning of each is recognizable and coherent.**

**22** Painting:
WHAM
by Roy Lichtenstein
(Tate Gallery)

**23** Film still:
BARBARELLA
with Jane Fonda
(Paramount Pictures Ltd)

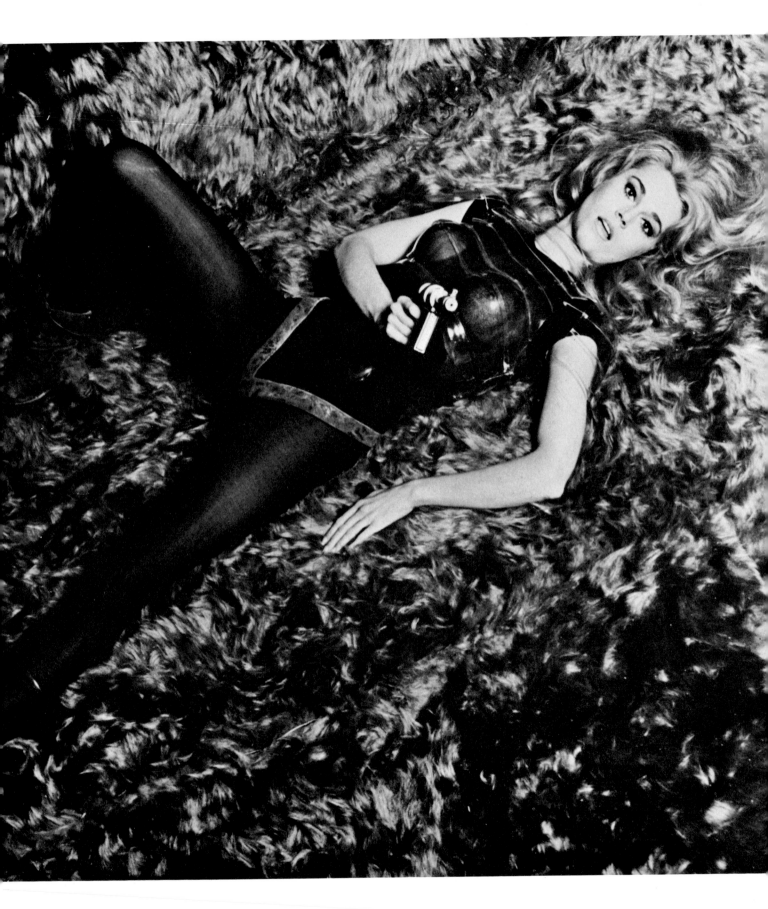

24 Sculpture:
BRONZE STATUE OF A CHARIOTEER
Ancient Greek
(photo: Martin Hürlimann, from
*Eternal Greece*
published by Thames & Hudson, 1953)

# CLASSICISM

classical [*klas*ikal] *adj* pertaining to, expert in, founded on, the language, literature, thought and civilization of ancient Greece and Rome; in accordance with accepted tastes and traditions; of recognized merit, critically satisfying; restrained, balanced, austere; (*of music, coll*) in any of the major styles of serious European music; not being light, popular, jazz, or folk music.

classicism [*klas*isizm] *n* (*gramm*) idiom or construction from Latin or Greek introduced into another language; classical scholarship; adherence to classical principles and taste in art and literature.

**The ordered nature of Classicism goes with an interpretation of life in which war can appear as an integrated part of man's experience, not as a unique discord – or an attractive adventure – in an otherwise normal existence. Classicism can contain tragedy without exaggeration or hysteria.**

Warriors do not appear as individuals, but as idealizations of human or elemental characteristics. They operate within the vast scheme of the universe; their forms and emotions reflecting archetypes of structure and morality greater than themselves.

The Renaissance was a high point in the subtlety of the Classical attitude. At that time, and against a background of political violence, an attempt was made to fuse the Christian and pagan traditions by means of aesthetic ideas. Artists and architects tried to discover the fundamental rules of proportion and form so as to apply them to the design of buildings, paintings and sculpture – even to weapons, fortifications and military strategy. It was a delicate tight-rope to walk, and in the end European art and thought fell into more extreme – more obvious – stylistic conventions.

Classicism has been more mauled by modern philosophy and science than any other aesthetic-cum-moral attitude. It is even difficult for us to 'read' historical Classicism without distortion; there is always the temptation to take apart the elements of the whole which Classicism presents. Allegories become propaganda in the twentieth-century interpretation – bits of an argument, not particular embodiments of fundamental values. For us, King Oedipus has become the archetype of a particular psychological orientation whereas he is really an archetype of pride. In looking today at Classical sculptures it is hard for us not to

**25** Rock painting:
detail from BATTLE OF ARCHERS
from Tahl in the Libyan desert
Prehistoric
(Frobenius Institute/Hamlyn Group)

**26** Drawing:
THE CONDOTTIERI
by Leonardo da Vinci
(British Museum)

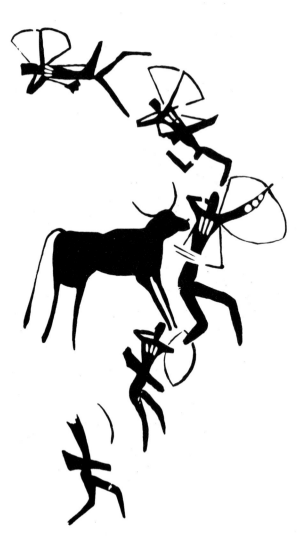

turn their meaning inside out. We try to see the man behind the idealization; the sculptor wanted us to see the idealization behind the man.

It is, however, possible to see the residue of Classicism operating in the development of modern design and architecture. Humanist attitudes still call for man to be the measure of expression and environment, even when they have abandoned the idea that man is made in God's image. But these beliefs can no longer accommodate the vast range of emotion and response of historical Classicism. The apparently Classical stillness of C R W Nevinson's first world war paintings seems to have an ironic rather than an affirmative meaning.

We cannot touch, in art or thought, the stoicism of these words spoken to Orestes by the Chorus in Aeschylus's play *The Choephori*:[3]

No man may hope to spend
His life untouched by pain
And favoured to the end.
Some griefs are with us now; others again
Time and the gods will send.

The functional levers that science and technology have given to men have made it impossible for them to want to resolve their suffering by such an accepting attitude. Consequently, Classicism today is a matter of practical application; it is incapable of absorbing the affront to rationality that war represents.

[3] From the Penguin edition first published in 1956 and translated by Philip Vellacott.

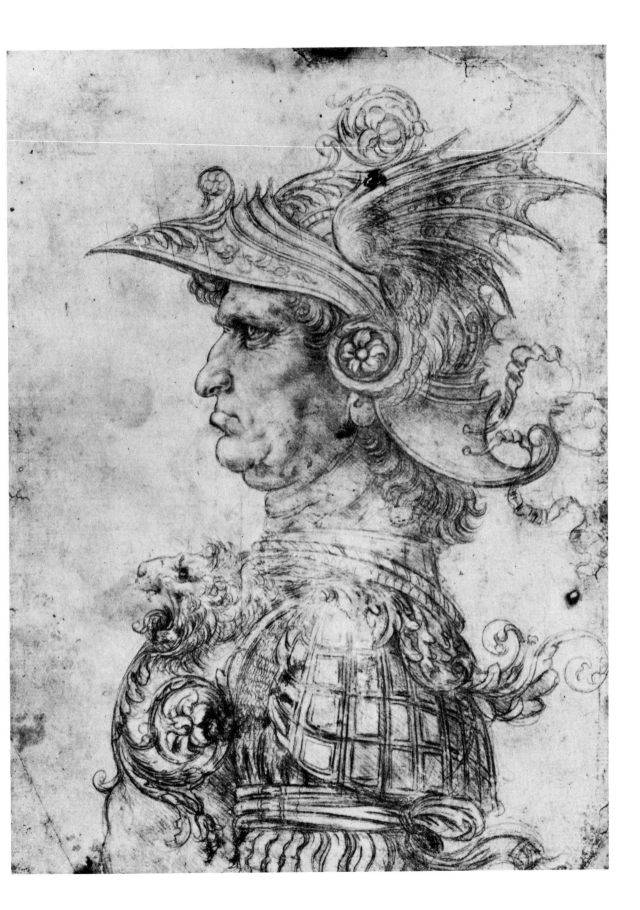

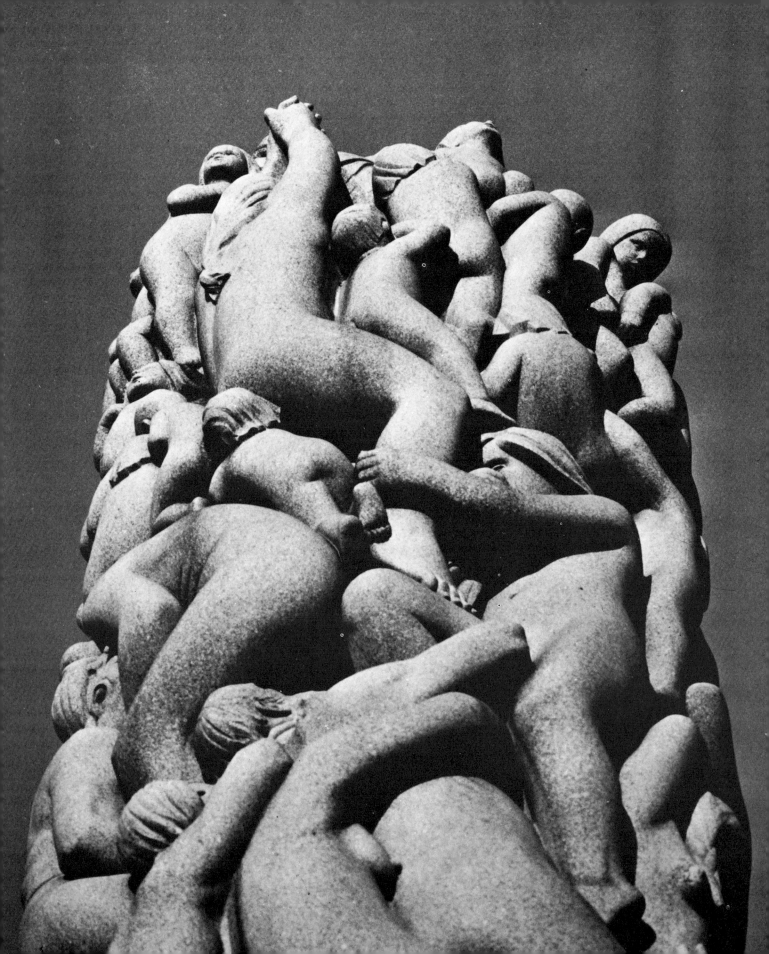

**27** Left
Sculpture:
CENTRAL COLUMN VIGELAND PARK, OSLO
by Gustav Vigeland
(photo: Ragnar Utne)

**28** Top right
Tactics diagram:
OUTMANOEUVRED
Air Technical Services
First World War
(Imperial War Museum: photograph by
Brian Gardiner)

**29** Bottom right
Painting:
FRENCH TROOPS RESTING 1916
by C R W Nevinson
(Imperial War Museum: photograph by
Brian Gardiner)

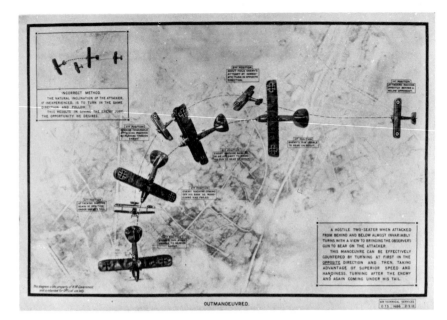

# ROMANTICISM

**romantic** [ROmantik/Romantik] *adj* of or like romance; of, like, dealing with or fit for idealized love or pleasing adventures; picturesquely strange; having mysterious charm, glamorous; emotional, sentimental; passionate; colourful and improbable; (*of literature, art or music*) showing romanticism ~ **romantic** *n* one whose outlook or behaviour is romantic; writer, artist or musician showing romanticism ~ **romantically** *adv.*

**romanticism** [ROmantisizin] *n* state or quality of being romantic; the production of romantic effects in any art; literary, artistic or musical movement that directly and unrestrainedly expresses or seeks to rouse personal emotions, or exploits the emotive power of exotic, mysterious, sentimental or sensational subjects; literary movement of the late 18th and early 19th centuries having these characteristics and claiming affinity with medieval literature; anti-classicism.

**Romanticism is one of the most widespread of twentieth-century attitudes. Exotic experience forms the hard core of entertainment from the spy drama to the comic book, and glamour is an aura surrounding products and buildings as well as people.**

Psychoanalysis destroyed Classicism by revealing that fantasy is embedded deep in the moral structure of mythology. But the discovery powerfully reinforces Romanticism. In addition, the involvement of technology in culture makes possible the realization of fantasy to an extent unbelievable before. Delacroix's MASSACRE AT SCIO cries out for the kind of movement, scale, noise and violence that only the cinema can provide. It asks for the context of an adventure story in which some of the characters in the foreground would already have participated. The episodes can be found in other pictures by Delacroix – incarceration in a harem, shipwreck, a lion hunt. It would be quite a movie, but there would be nothing original about it – the genre dates back to the beginnings of Hollywood.

The representation of war inevitably plays a big part in Romanticism. War provides the perfect conditions of extremity and terror. It provides the basis of adventure which requires that a hero or heroine be caught up in events beyond their control. Typically, adventure stories end at the moment of success; when the hero has won through and normality has been restored there is nothing more to tell. It is in some ways futile to criticize modern Romanticism's absurdities. To say, for example, that it is shallow because the heroine's lipstick is only smudged and her dress only torn to just above the nipples, even though she is supposed to have narrowly escaped being flogged and

**30** Opposite
Comic:
panel from IT WALKS LIKE A MAN
(Marvel Comics Group, Vista
Publications Inc., New York)

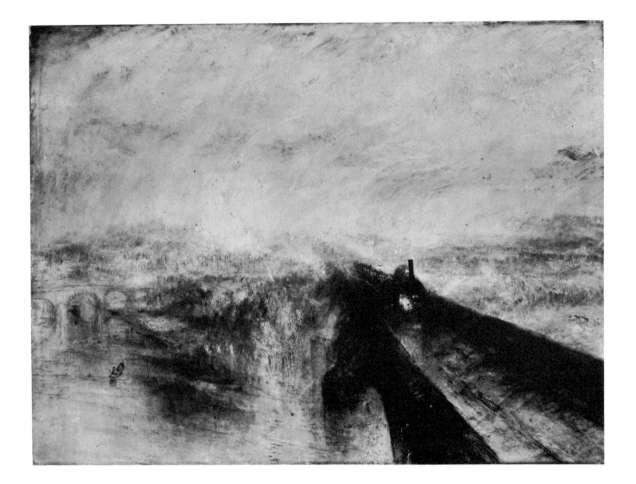

**31** Above
Painting:
RAIN STEAM AND SPEED, GREAT WESTERN
RAILWAY
by J M W Turner
(National Gallery)

**32** Top right
Photograph:
200TH MINUTEMAN II ICBM BLASTS OFF
by 13–2d Photo Group
(United States Air Force Photo)

**33** Bottom right
Painting:
PARACHUTES
by Eric Kennington
1941
(Imperial War Museum: photograph by
Brian Gardiner)

raped. That is what this kind of Romanticism is for.
Chocolate layer cake has a different flavour from army rations.

**Romanticism is vicarious; it seeks sensation for its own
sake. That sounds like a condemnation, but it may not be.
It is more likely that the ramshackle mess of Romanticism's
involvement in technological society is the essential result
of more leisure and dull work.**

It is possible to catch echoes of Romanticism everywhere.
In many ways the motive power behind student revolt is
disgust at the expediency and related rationality that goes
with technological bureaucracy. A revolution, like a war,
provides a seductive dream medium for romance. At the
opposite extreme, monolithic organizations try to preserve
links with periods in their history when they were concerned
with adventure and exploration. High technology itself
has a strong ability to identify with the romance inherent
in its power to battle with nature. Turner's RAIN,

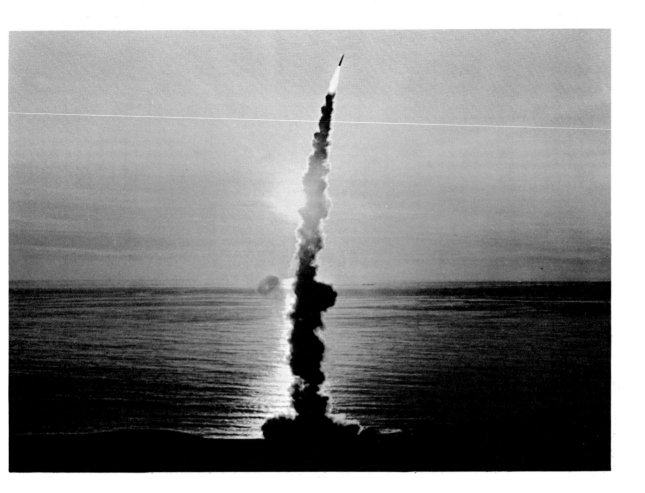

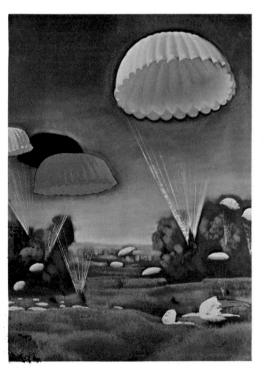

STEAM AND SPEED is a natural ancestor of the U.S. Air Force's superb photograph of an intercontinental ballistic missile rising against the sunset.

Because Romanticism today goes so deep it supports a complex layer of comment and involvement. A painting like WHAM is romantic, but it is also a revealing statement about Romanticism. It works from inside the attitude it is a comment on and is, therefore, ambiguous in its meaning. James Thurber's short story, *The Secret Life of Walter Mitty*, affects us in a similar way. The truth and irony of what Thurber has to say about the technological dream world used by Mitty to escape his dull suburban life does not destroy our own involvement in the same dream. Rather we recognize Mitty's problems and attitude as our own:

. . . The pounding of the cylinders increased: ta-pocketa-pocketa-pocketa-POCKETA-POCKETA. The Commander stared at the ice forming on the pilot window. He walked over and twisted a row of complicated dials.

"Switch on No.8 auxiliary!" he shouted. "Switch on No.8 auxiliary!" repeated Lieutenant Berg. "Full strength in No.3 Turret!" shouted the Commander. "Full strength in No.3 Turret!" The crew, bending to their various tasks in the huge, hurtling eight-engined Navy Hydroplane, looked at each other and grinned. "The Old Man'll get us through", they said to one another. "The Old Man ain't afraid of Hell!"

"Not so fast! You're driving too fast!" said Mrs Mitty. "What are you driving so fast for?"

The subtlety of Walter Mitty's dream world can be well experienced in peaceful bars and sitting rooms where, relaxed and quiet, people retell stories about their wartime selves. Often nostalgia for a lost intensity is as strong as relief at the passing of danger or terror. Romanticism exists as the tangible expression of men's identification with figures of superhuman ability and violence, sexual prowess and ecstasy. The vision of the hero, and the acting out of heroic roles through art, literature and play, are Romanticism's epitome.

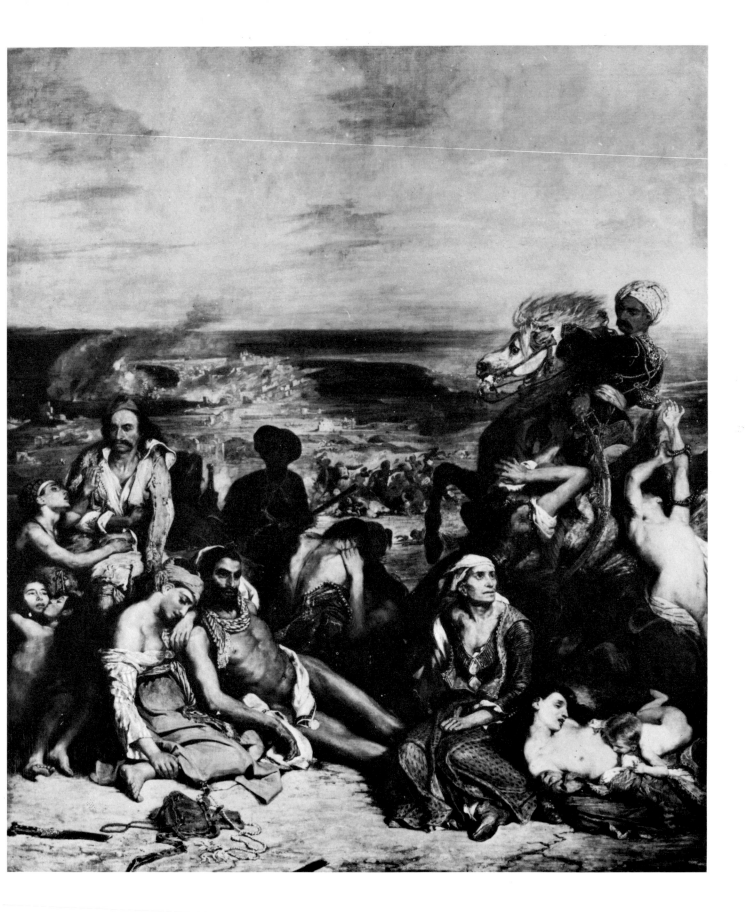

**36** Film still:
from THE TRAIN with Burt Lancaster
John Frankenheimer
(National Film Archive)

**37** MODEL SOLDIER
(Lynn Sangster/Historex)

**38** Poster card:
TIME FOR ONE MORE
for Mitchell's Golden Dawn cigarettes
First World War
(Imperial War Museum)

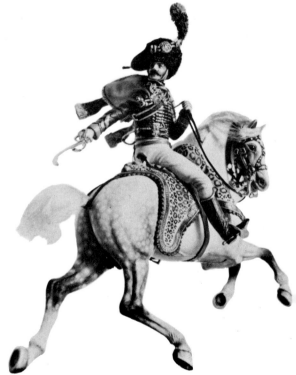

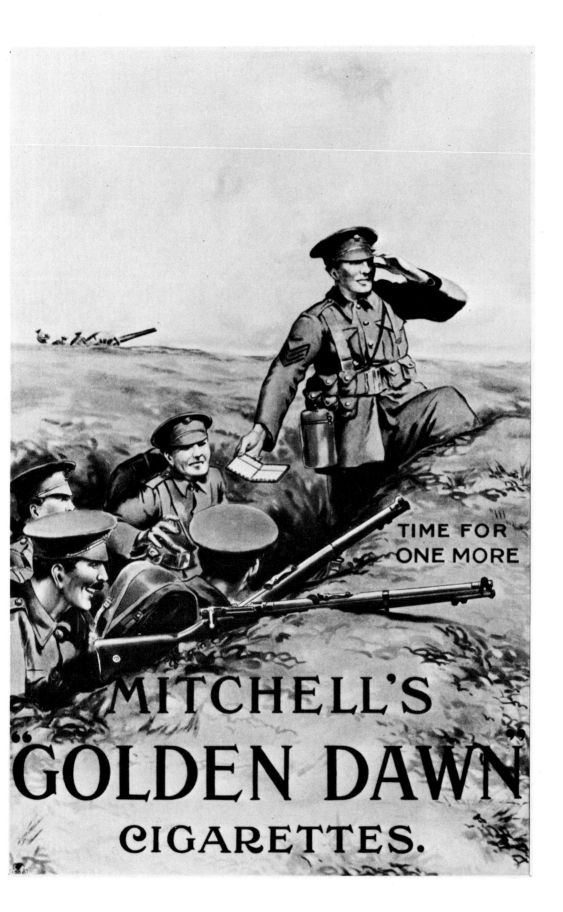

**39** Photographs:
WAR GAMES IN SOUTH WALES
Specially photographed for the book
by Julian Sheppard

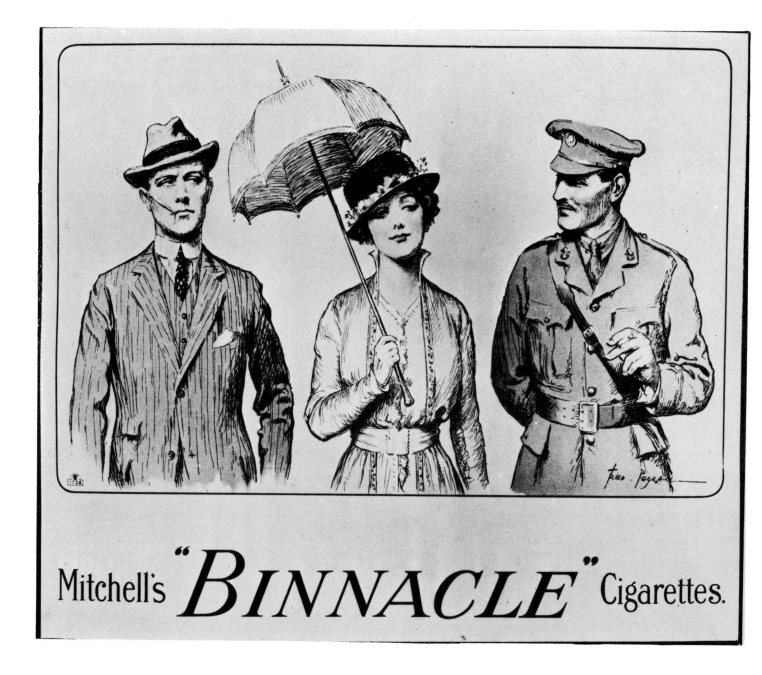

Mitchell's "BINNACLE" Cigarettes.

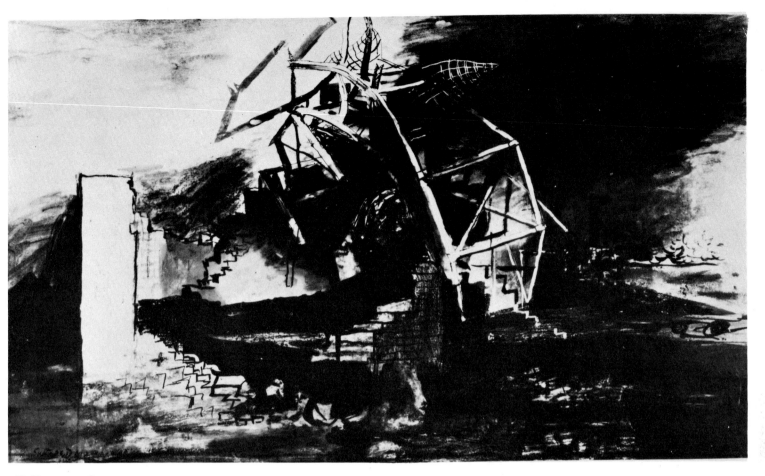

**40** Poster card:
for MITCHELL'S BINNACLE CIGARETTES
by Fred Pergain
First World War
(Imperial War Museum)

**41** Painting:
THE CITY: A FALLEN LIFT SHAFT
by Graham Sutherland
1941
(Imperial War Museum)

**42** Sculpture:
THE DRUMMER BOY
(National Museum of Wales)

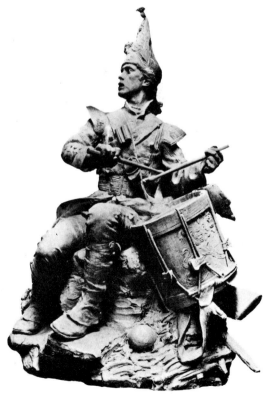

**43** Photograph:
DRESDEN AFTER ALLIED AIR RAIDS
by Richard Peter
Second World War
(Richard Peter)

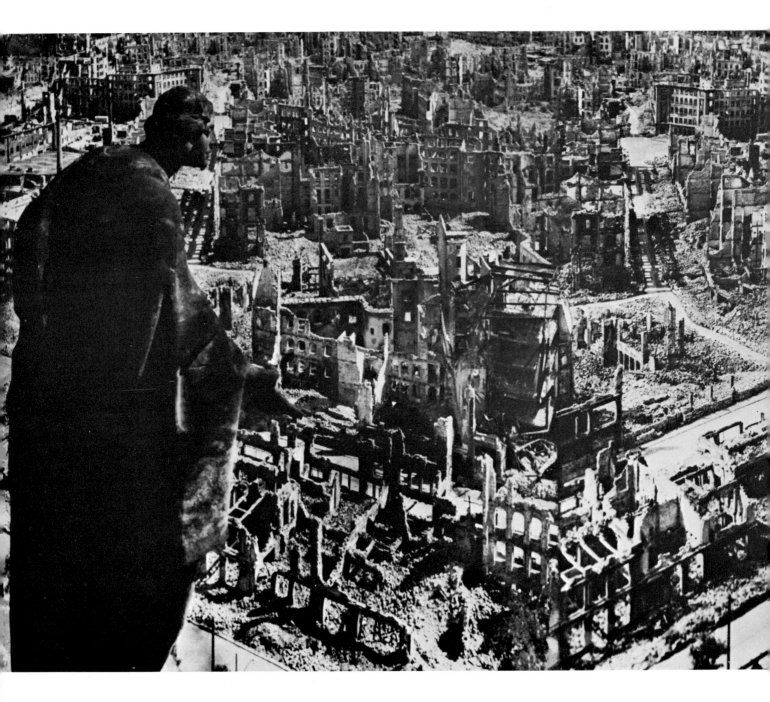

# REALISM

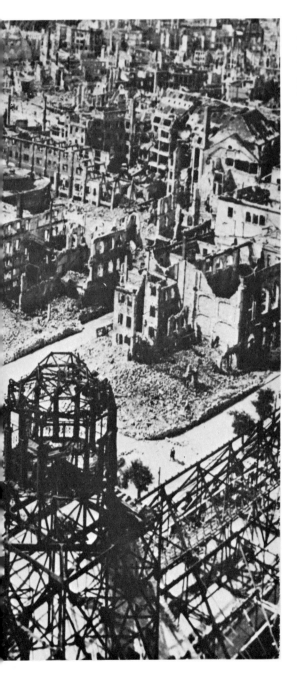

Expressionism and Realism sometimes seem closely linked because the part of the dictionary definition of Realism which says 'attempt to describe in literature or art some fact as it actually is, ESP. IN ITS UNPLEASANT ASPECTS . . .' has always been accurate. Unpleasant aspects and details have absorbed realist artists because they have appeared to be an antidote to dangerous illusion and empty sentimentality.

It is only with a painter of Bruegel's stature that Realism ever comes near to realizing its impossible programme of descriptive accuracy and neutrality of judgement.

**Realism should be able to see everything. The glory of war as well as its folly. The courage as well as the waste. Unlike Classicism, it does not equate these human emotions with universal archetypes, but with the small lives of men. It is characteristic of Bruegel's pictures of climactic events like the suicide of Saul that the action is contained in a vast landscape where other men are doing other things. Realism is Classicism turned on its head; it is a world where the particular stands only for itself, where minute detail is accepted as important and revealing, not as distracting.**

Although Realism has a long history, it is an attitude that has received impetus from scientific modes of enquiry and from the development of photography and cinema. Before the invention of the camera, every representation of a battle, or a soldier in a battle, required the recreation – the reconstruction – of the scene in the form of a painting or sculpture. For centuries, the work of artists was integrated in the mechanism of state and church power and the language of their art rarely permitted the idea of questioning that power. The invention of printing was a decisive moment, but it was photography that finally made

**44** Below
Painting:
SERGEANT S COX
by Eric Kennington
1941
(Imperial War Museum: photograph by
Brian Gardiner)

**45** Right
Photograph:
TROOPERS OF A COY, 327 INFANTRY
BRIGADE, 101 AIRBORNE DIVISION,
US ARMY IN VIETNAM
by Sgt Sam Wallace
(MACOI)

**46** Opposite
Photograph:
THE LAST MAN TO DIE
by the late Robert Capa
of Magnum Photos

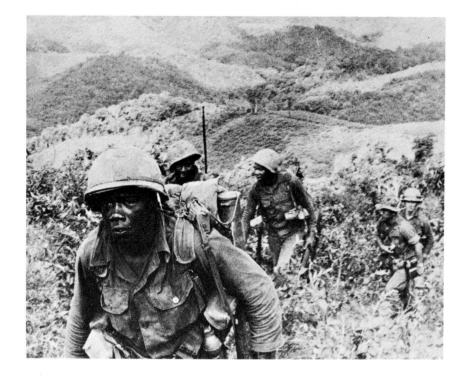

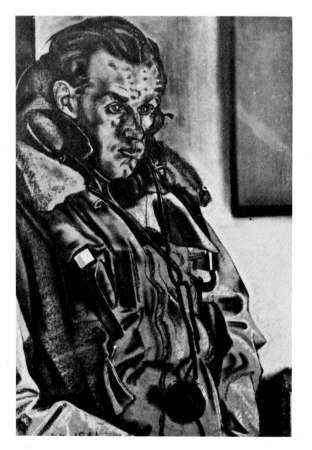

the suffering of the common soldier as widely accessible as
the portrait of the brave and wise general or the aesthetic
grandeur of the set-piece battle picture.

Mangled remains, photographed lying in a pool of drying
blood, show just death alone. The round shocked eyes
staring from below the bandages show just individual
weariness and loss. The symbolic myth of war and glory is
not necessarily destroyed, but the human aftermath is
nakedly exposed. Tim O'Sullivan's photograph of a dead
Confederate soldier taken in the American Civil War says
the same as Robert Capa's THE LAST MAN TO DIE
taken eighty years later.

However, it is important to realize that the camera is not
in any sense an automatic producer of Realism, and that
Realism is not automatically interchangeable with anti-war
propaganda. Although the camera is uniquely important in
the development of Realism, photography and cinema are
capable of an immense range of imagery. The cinema, in
practice, is far more romantic than realistic. What is true,
is that the combination of the camera with the mass media
gives an enormous potential for communicating vividly the

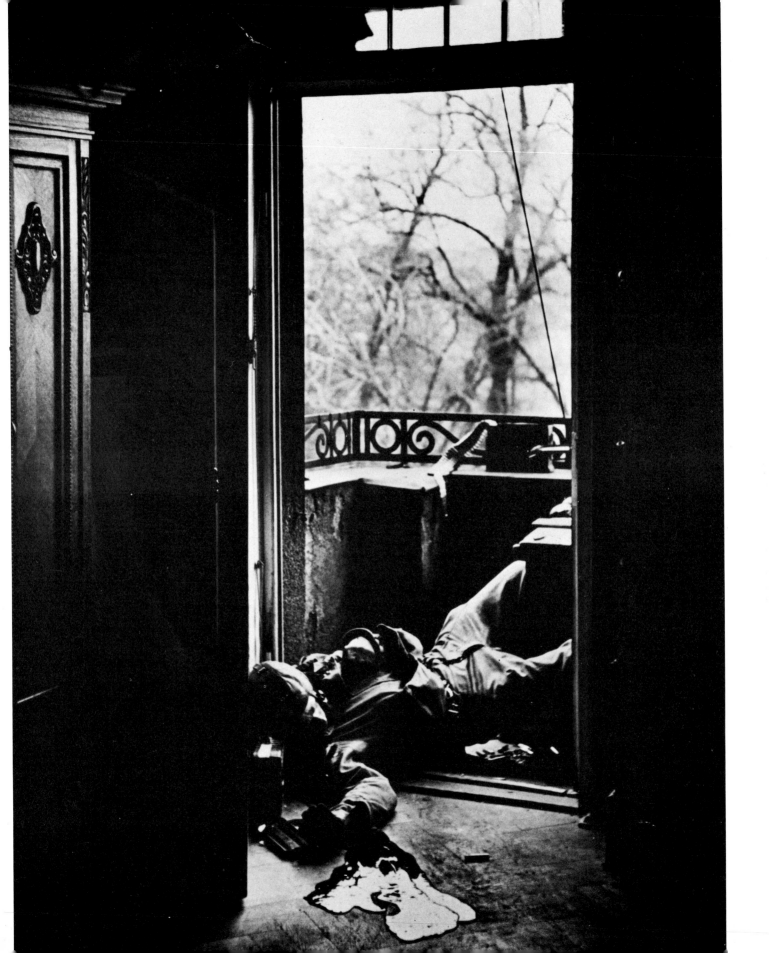

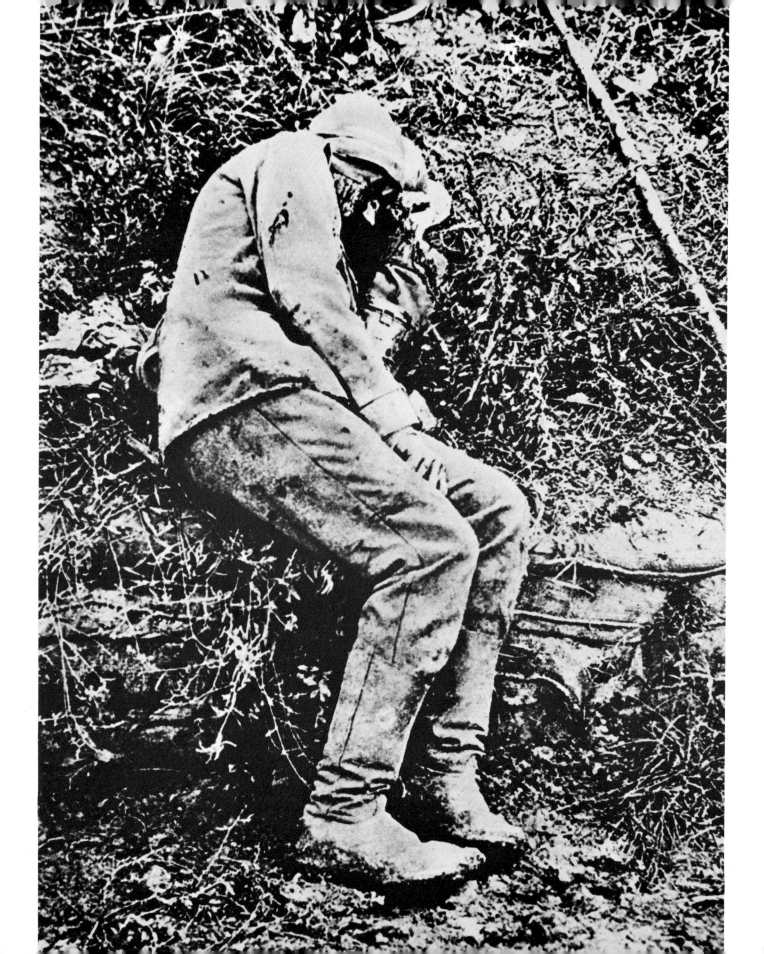

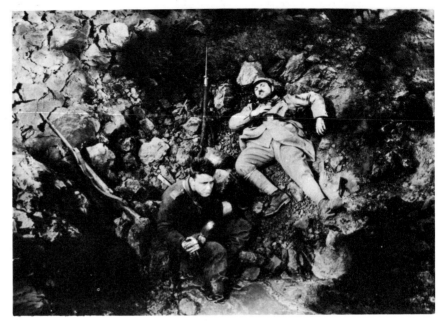

**47** Left
Photograph:
ICH HATTE EINST EIN SCHÖNES
VATERLAND; ES WAR EIN TRAUM
as published in *The First World War –
A Photographic History*
(Daily Express Publications 1933)

**48** Right
Film still:
from ALL QUIET ON THE WESTERN FRONT
Lewis Milestone
(National Film Archive)

**49** Below
Detail of cartoon:
THE RECRUIT WHO TOOK TO IT KINDLY
by John Bateman
First World War
(Reproduced by permission of *Punch*)

fact that war is messy and brutal. When there is added the possibility of reporting through newspapers and other media that are to some degree independent of the state, something exists which is quite new in the history of ideas. The role played by film and television in reporting during the recent Czech crisis shows something of what could happen in the future.

**At this point, however, the wheel comes full circle and Realism's clarity in reporting is clouded by the technological inventions that have made possible its fuller development. The situation is particularly acute in television where the mixture of entertainment with news and documentary is ubiquitous. It is not so much that an individual presentation may be distorted by the necessities of the medium, but that the sequence of programmes can destroy objectivity and distort the significance of events.**

Writing recently in *The Listener*[4], Krishan Kumar gave a good example of what can happen:

. . . A National Commission on Violence heard that the average American between the ages of two and 65 spends nearly nine years of his life simply

[4] The Political Consequences of Television by Krishan Kumar, *The Listener*, 3 July 1969, Vol 82, No 2101.

**50** Painting:
THE SUICIDE OF SAUL
by Pieter Bruegel
1562
(Kunsthistorisches Museum, Vienna)

sitting watching television. He sees, on average, an incident of violence every 14 minutes and a killing every three-quarters of an hour.

Much of this violence is political. In a current British study children were asked what programmes they associated most with killings. Many replied: "The News".

Here what seems to be the characteristic pessimism of Realism is being multiplied on an enormous scale and communicated by a powerful medium that provokes involvement over the tea-table and the coffee-cups. Nobody can yet say if this blunts or sharpens its impact: what is certain is that its effect on people cannot be judged by a discussion of individual programmes in isolation. On television, Realism and Romanticism, true statement and vicarious experience, are locked together to provide what an American professor of sociology calls (next to the H-bomb) 'the most dangerous thing in the world today'.

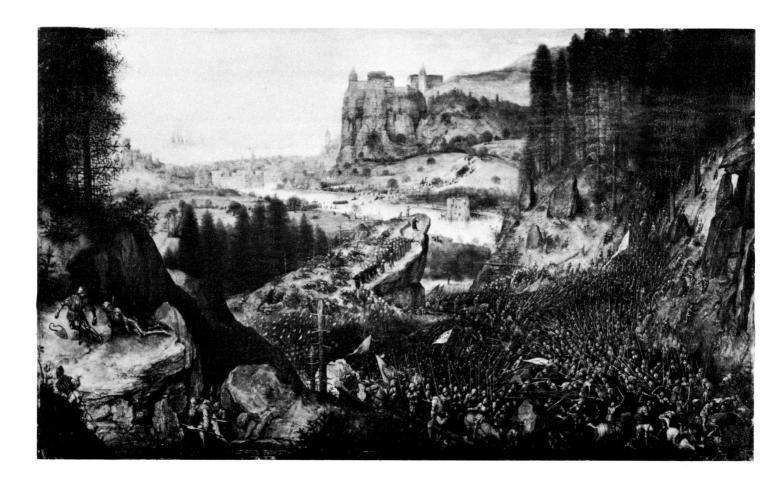

**51** Photograph:
INDIAN SOLDIER
by Christa Armstrong
(Christa Armstrong)

**52** Photograph:
SEVENTH FLEET AMPHIBIOUS ASSAULT FORCE
LANDING ON A BEACH IN VIETNAM
by Jean C Cote
(US Navy)

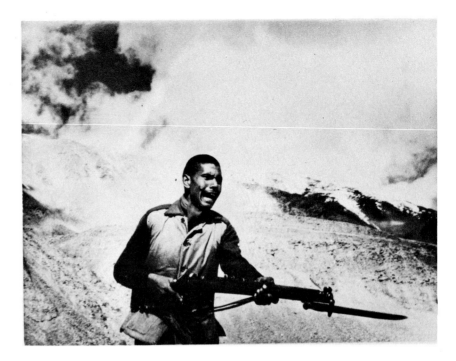

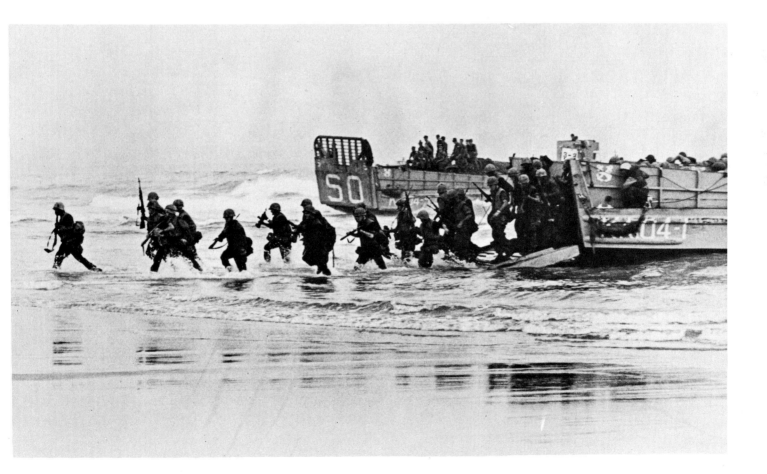

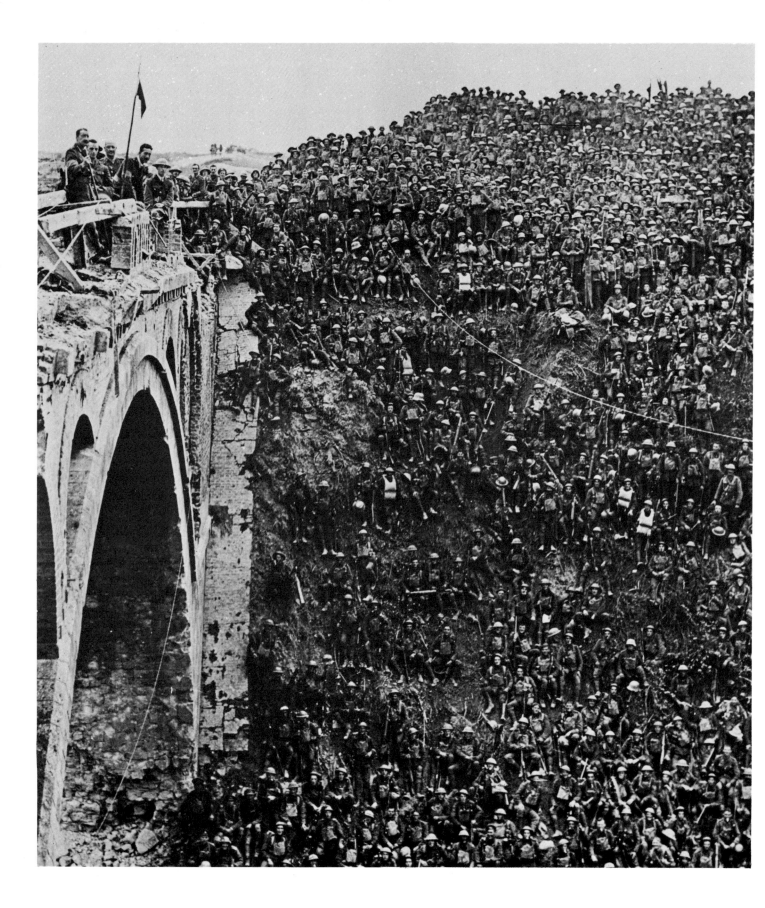

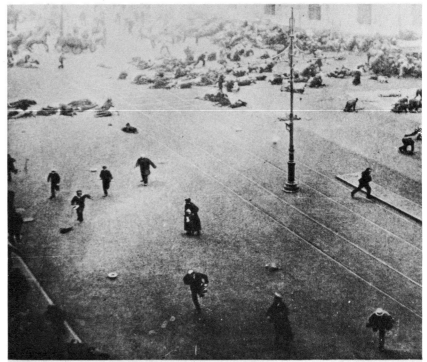

53 Left
Photograph:
RIQUEVAL BRIDGE 1918
(Imperial War Museum)

54 Above
Photograph:
RIQUEVAL BRIDGE 1968
(Imperial War Museum)
These two photographs are from a series of
exhibitions organised by the Imperial War Museum
showing scenes in the First World War alongside
specially taken photographs of the same locations
fifty years later.

55 Top right
Photograph:
JULY 17, 1917, BEGINNING OF
THE RUSSIAN REVOLUTION
by John Massey Steward
(Camera Press, London)

56 Bottom right
Photograph:
ALLIED PLANNING CONFERENCE
Second World War
(Imperial War Museum)

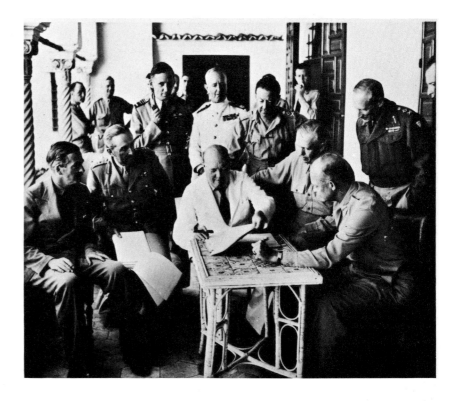

**57** Below
SOVIET BANNER
(Imperial War Museum: photograph by
Brian Gardiner)

**58** Top right
Flag:
HOMMAGE DE DEUX HUMBLES FEMMES
BELGES À L'ANGLETERRE
First World War
(Imperial War Museum: photograph by
Brian Gardiner)

**59** Below right
Medals and decorations:
BRITISH, GERMAN, SERBIAN, BELGIAN,
ITALIAN, FRENCH, FINNISH AND POLISH
(Imperial War Museum: photograph by
Brian Gardiner)

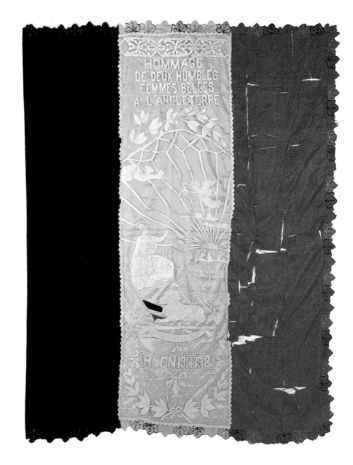

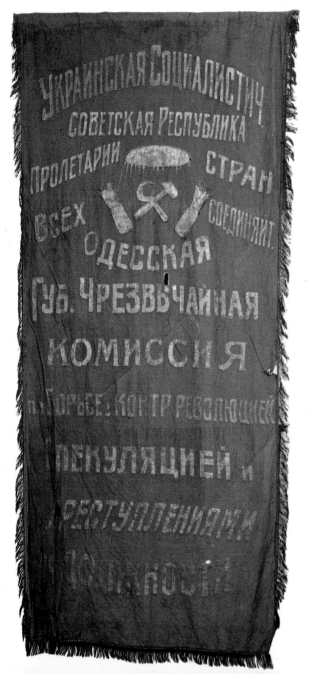

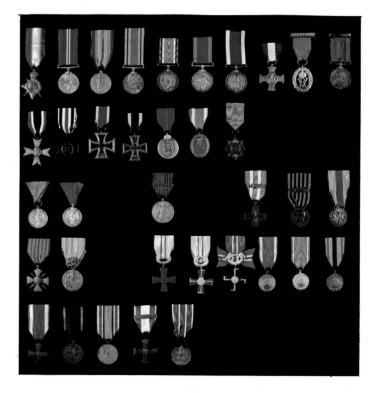

# SYMBOLISM

**symbol** [*sim*bol] *n* any object, design, sign, act *etc* conventionally accepted as representing some person, abstract idea or quality *etc*; letter, figure, sign *etc* used to express a sound, a mathematical quantity or process, a chemical element *etc*; (*psych*) indirect representation of unconscious material > PDP.

**symbolism** [*sim*bolizm] *n* representation by symbols; system of symbols; act of symbolizing; French literary movement aiming to suggest rather than depict reality ~ **symbolist** *adj* and *n*.

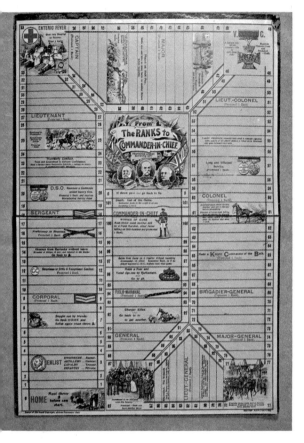

**60** Board game:
FROM THE RANKS TO COMMANDER-IN-CHIEF
1905
(Museum of Childhood, Edinburgh: photograph by Brian Gardiner)

**Symbolism is intimately involved in the conceptual framework which makes war possible. It provides a visual means of expressing the abstract national and religious ideas which hold together the individual and the group. The basic multiplication table from one soldier to platoon, to company, to regiment, to nation depends on a complex structure which must somehow be made comprehensible if it is to work. At bottom, even the existence of war can be seen to be dependent on the effectiveness of Symbolism and its associated rhetoric.**

Stephen Crane's story *The Red Badge of Courage* is one of the most vivid representations of large-scale war in literature and one of its fundamental insights is into the identification which Symbolism supports:

Once the youth saw a spray of light forms go in houndlike leaps towards the waving blue lines. There was much howling, and presently it went away with a vast mouthful of prisoners. Again, he saw a blue wave dash with such thunderous force against a grey obstruction that it seemed to clear the earth of it and leave nothing but trampled sod. And always in their swift and deadly rushes to and fro the men screamed and yelled like maniacs.

This small extract contains much that explains the purpose of military forms of art. Even today blue and grey symbolize for Americans the clash between two decisively opposed traditions of life. The 'Thin Red Line' description of Britain's small army at the height of her imperial power, carries the same kind of tense meaning. So did the crosses of the crusaders. So did Rome's eagles. Behind the banners and insignia, behind the unique rousing power of national or religious war hymns, behind the martial ballet of the drill square, behind a thousand symbolic devices designed to sink individual identity in that of the religious or national group, lies the central tenacity and meaning of militarism.

**61** Below
Sculpture:
SPIRIT OF THE CRUSADERS
by G Meredith Williams
(National Museum of Wales)

**62** Wood figures:
DISENCHANTED
by Private Boudard
1917
(Imperial War Museum)

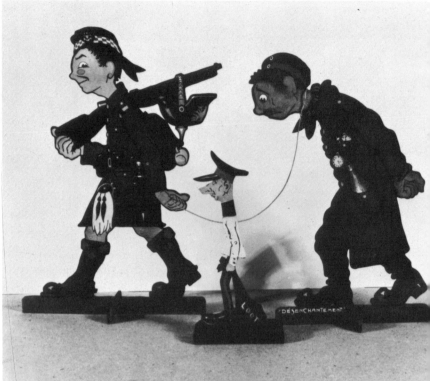

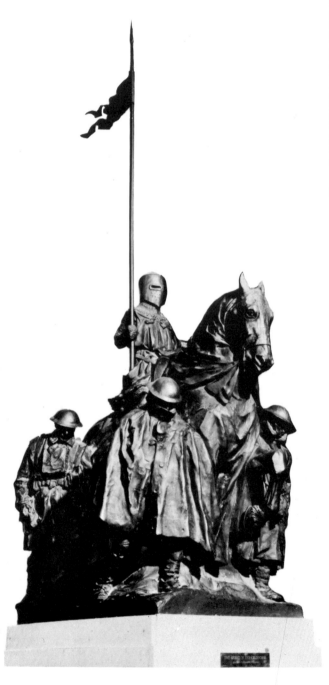

Anybody who has ever been to a vast parade of soldiers, or seen a fly-past or a fleet of warships can feel in touch with the immensity of the emotions that are locked up in these spectacles and reinforced by them. At this point, and with a frightening intensity, the concept of violence between nations and the cultural forms which support that violence, merge with the whole question of national and individual identity.

Once more unto the breach, dear friends, once more;
Or close the wall up with our English dead! . . .
Dishonour not your mothers; now attest
That those whom you call'd fathers did beget you!
Be copy now to men of grosser blood,
And teach them how to war. And you, good yeomen,
Whose limbs were made in England, show us here
The mettle of your pasture; let us swear
That you are worth your breeding; which I doubt not;
For there is none of you so mean and base
That hath not noble lustre in your eyes.
I see you stand like greyhounds in the slips,
Straining upon the start. The game's afoot:
Follow your spirit; and, upon this charge
Cry 'God for Harry, England and Saint George!'

**63** PHOTOGRAPH
from *The First World
War – A Photographic
History*
(Daily Express
Publications, 1933)

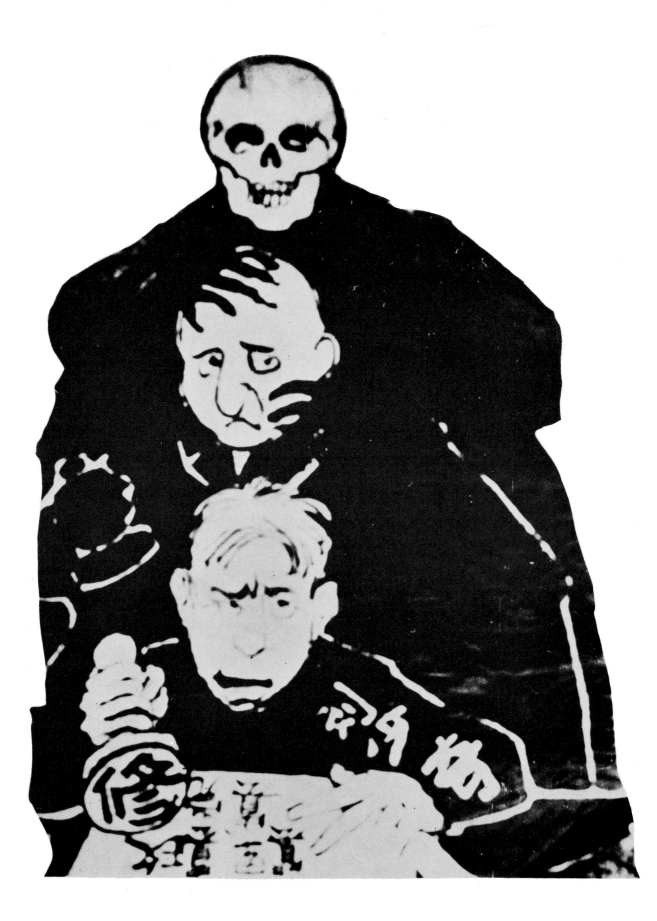

**64** Detail from poster:
RED GUARD POSTER
(Central Press Photos Ltd)

**65** Poster:
TELL THAT TO THE MARINES
by James Montgomery Flagg
First World War
(Welsh Arts Council)

**66** Poster:
THE HUN – HIS MARK
by J Allen St John
(Welsh Arts Council)

**67** Poster:
USA – EVERY CRIMINAL LEAVES
HIS MARK
by E. Kaxhdan
1966
(Welsh Arts Council)

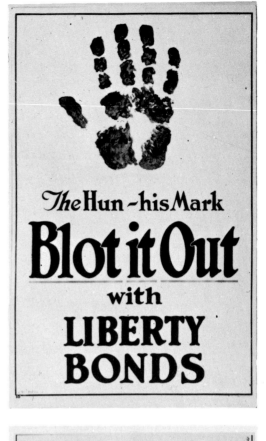

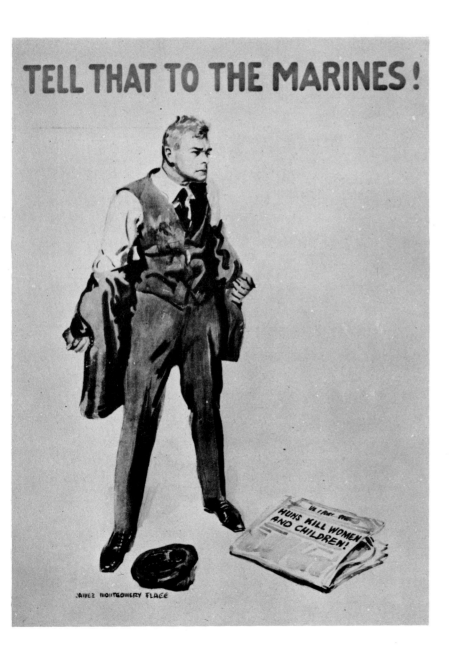

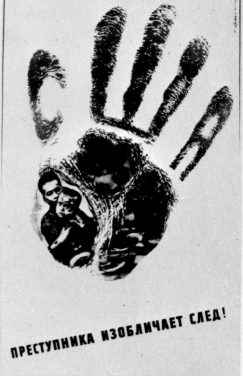

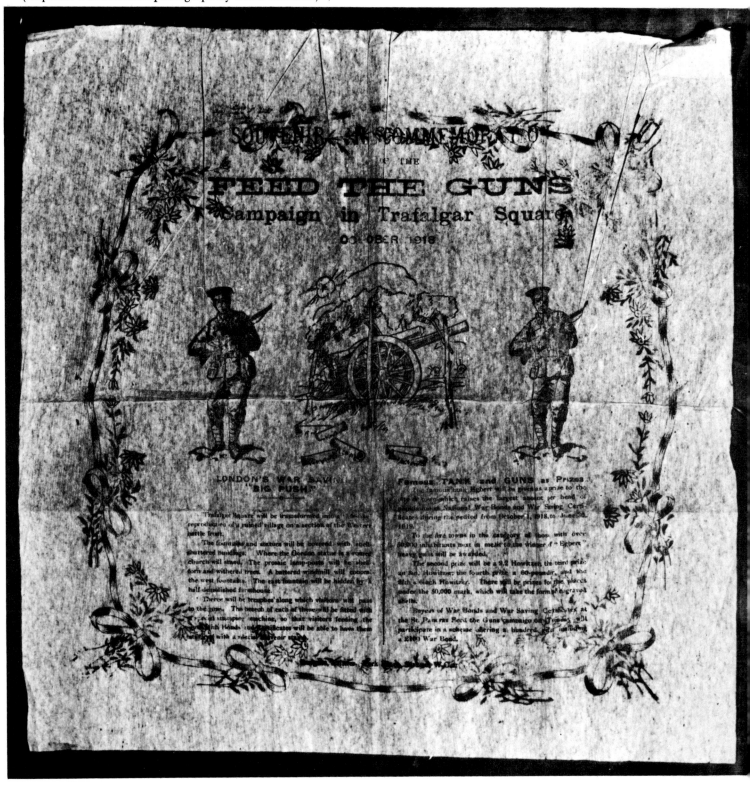

**69** Poster:
WILL THEY NEVER COME!
published by the Associated
Newspapers Ltd
1914
(Imperial War Museum)

**70** Poster:
FRAUEN UND MÄDCHEN! SAMMELT
FRAUENHAAR!
Women and girls! Collect your hair!
First World War
(Imperial War Museum)

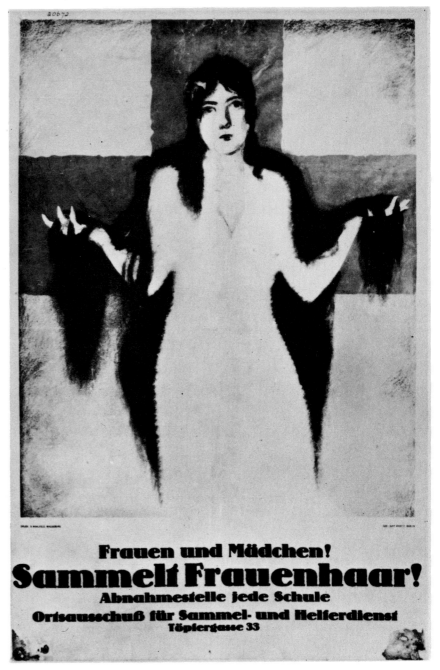

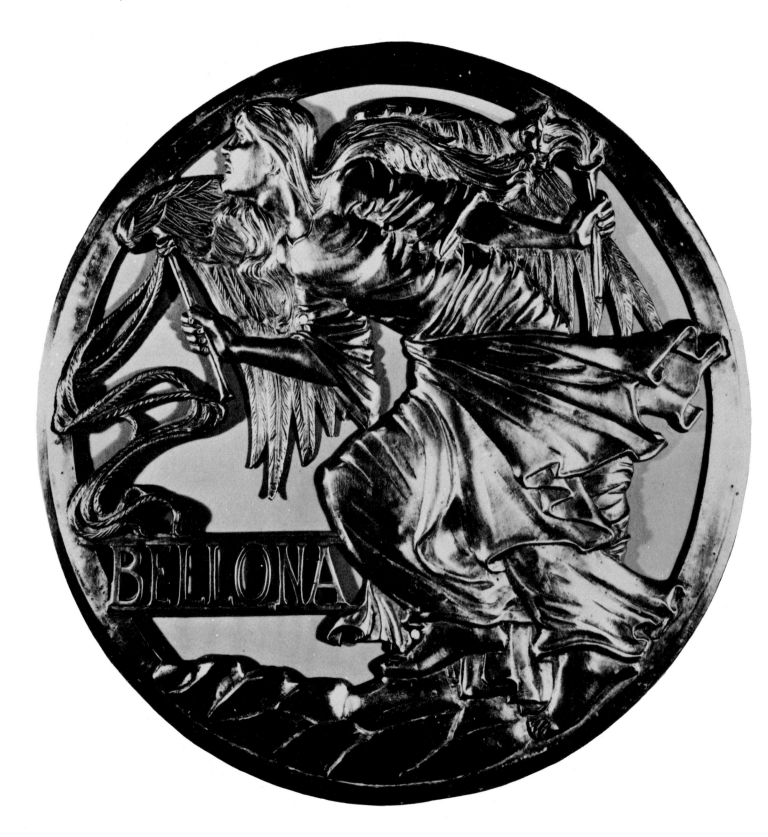

**72** FORMATION FLASHES
(Imperial War Museum: photograph by
Brian Gardiner)

**73** Detail of photograph:
HAPPY BIRTHDAY HO
by S/Sgt Looney
(US Marines)

**74** DRUM SHELL
(The Royal Regiment of Wales:
photograph by Brian Gardiner)

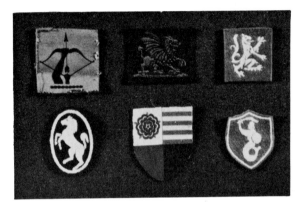

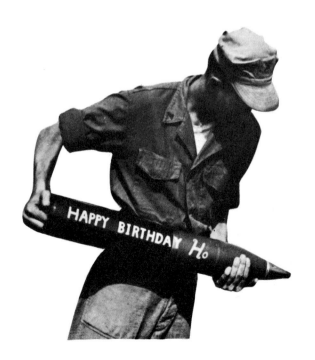

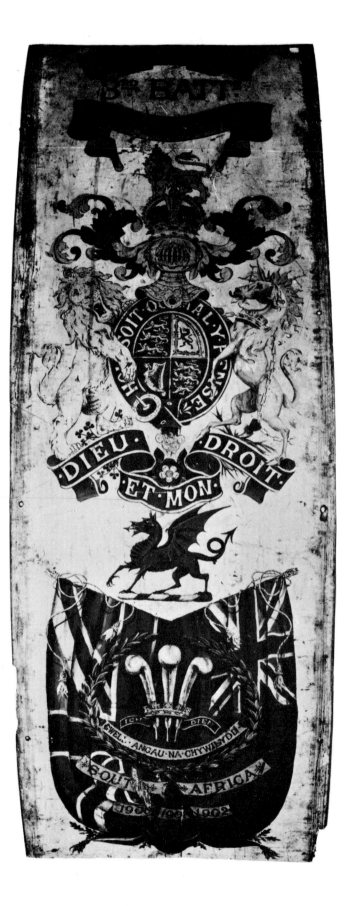

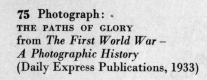

**75** Photograph: ·
THE PATHS OF GLORY
from *The First World War –
A Photographic History*
(Daily Express Publications, 1933)

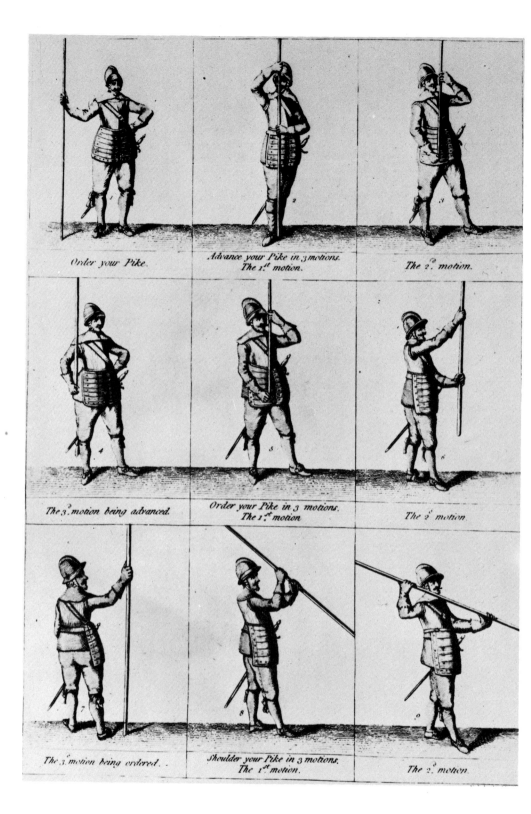

Order your Pike.

Advance your Pike in 3 motions.
The 1st motion.

The 2d. motion.

The 3d. motion being advanced.

Order your Pike in 3 motions.
The 1st motion

The 2d motion.

The 3d motion being ordered.

Shoulder your Pike in 3 motions.
The 1st motion.

The 2d. motion.

Charge to the Rear in 3 motions. The 1ˢᵗ motion.

The 2ᵈ motion.

The 3ᵈ motion being charged.

Recover your Pike & Shoulder in 3 motions. The 1ˢᵗ motion.

The 2ᵈ motion.

The 3ᵈ motion being Shoulder'd.

Order your Pike.

Cheeke your Pike. The 1ˢᵗ motion.

The 2ᵈ motion being Cheek'd.

**77** Printed leaf:
PROPAGANDA DROPPED FROM AIRCRAFT
Second World War
(Auckland Collection/The Psywar Society)
Dropped over Germany in December 1941.
The text reads 'in Russia the fallen leaves cover
fallen soldiers – and snow covers the leaves which
cover the fallen soldiers'

**78** Printed leaf:
PROPAGANDA DROPPED FROM AIRCRAFT
Second World War
(Auckland Collection/The Psywar Society)
Dropped by the Germans over the Maginot and
Siegfried Lines in Autumn 1939. The text reads
'Autumn. The leaves are falling. We will fall like
them. The leaves die because God wants it, but we
fall because the English want it. Next Spring
nobody will remember either the dead leaves or
the dead soldiers'

**79** Propaganda jigsaw:
ANTI-SEMITIC PUZZLE
German, Second World War
(Auckland Collection/The Psywar Society)

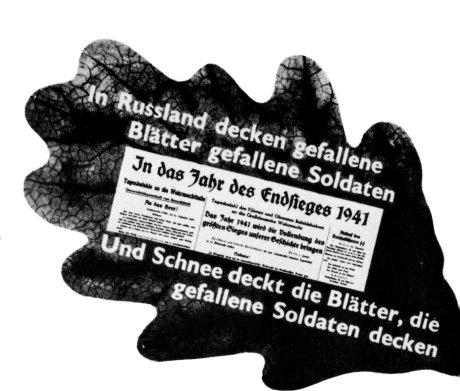

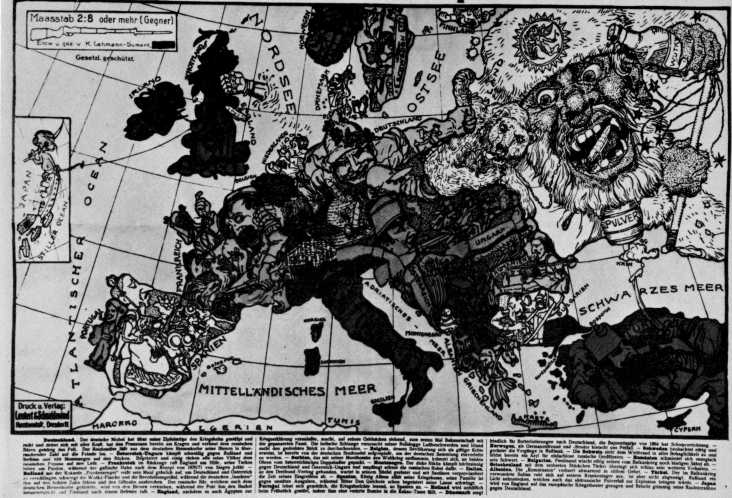

# Humoristische Karte von Europa im Jahre 1914.

**80** Above
Map:
HUMORISTISCHE KARTE VON EUROPA IM
JAHRE 1914
(Imperial War Museum)

**81** Top right
Print:
THE JAPANESE GENERAL YAMADA'S ARMY
OCCUPYING THE CHIUO FORTS AT TSINGTAU
First World War period
(Imperial War Museum)

**82** Bottom right
HITLER DOLL
Second World War
(Imperial War Museum: photograph by
Brian Gardiner)

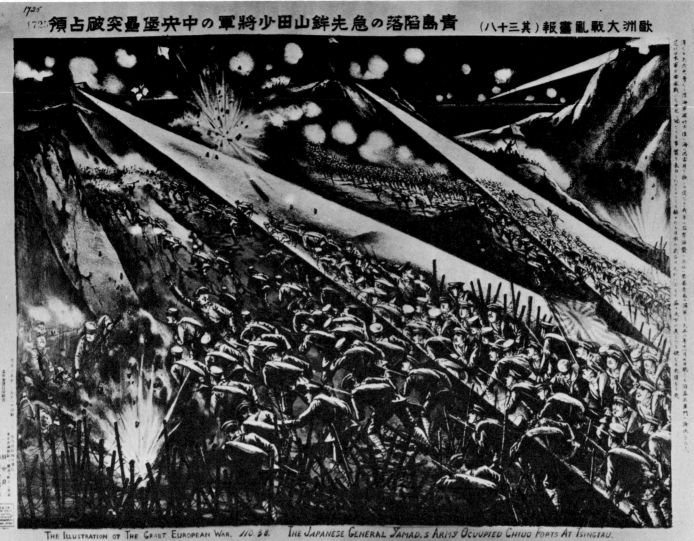

THE ILLUSTRATION OF THE GRAET EUROPEAN WAR. NO. 38. THE JAPANESE GENERAL JAMAD.S ARMY OCUUPIED CHIUO FORTS AT TSINGTAU.

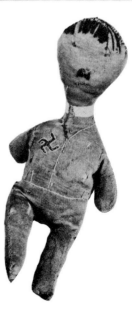

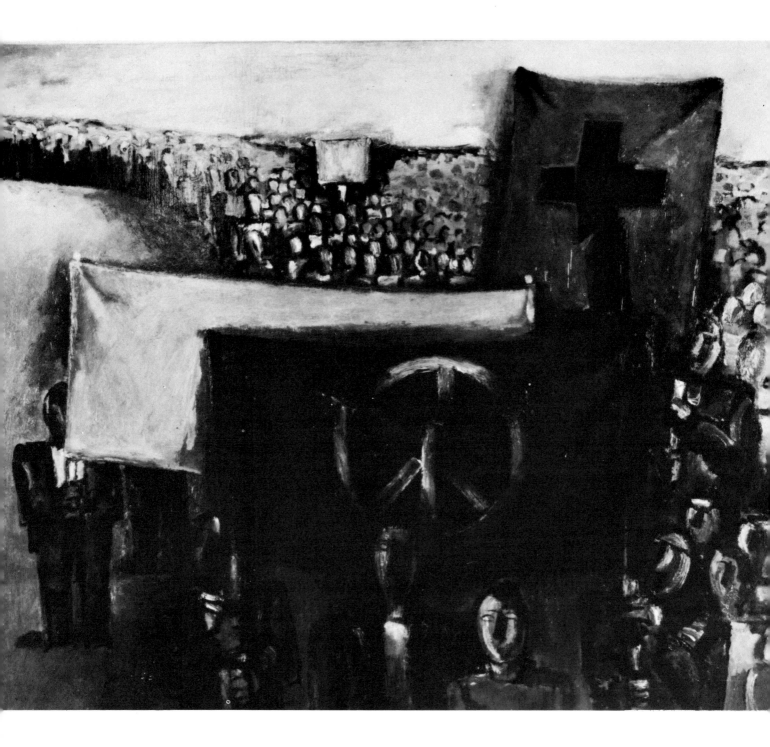

**83** Painting:
ALDERMASTON 1962–63
by Josef Herman
(Josef Herman: photograph by Brian Gardiner)

**84** Poster:
END BAD BREATH
by Seymour Chwast
(Push Pin Studios Inc)

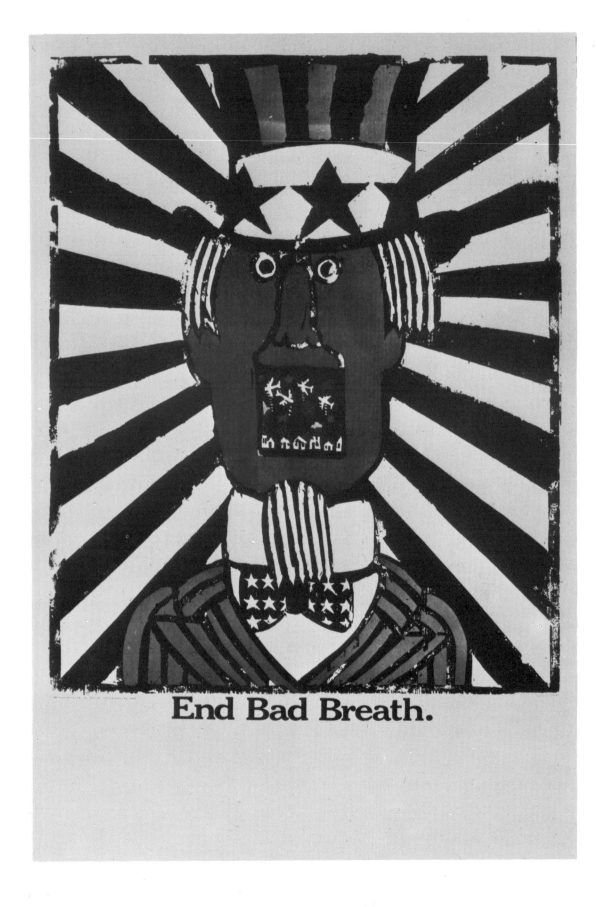

**End Bad Breath.**

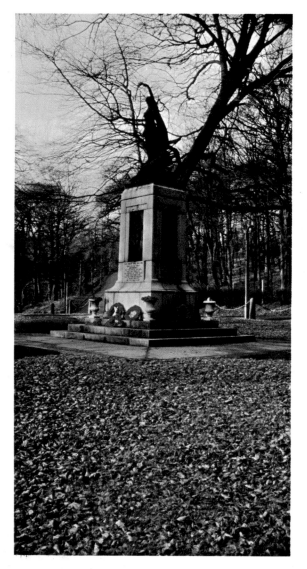

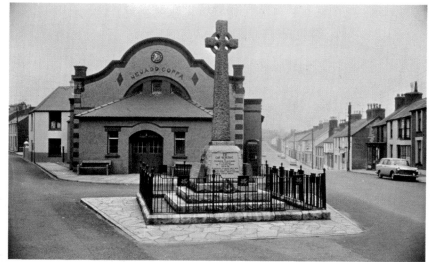

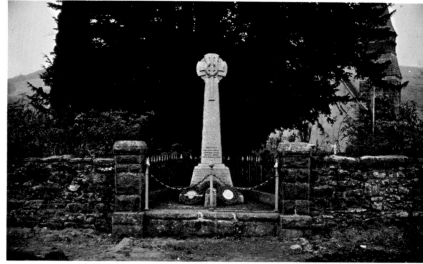

**85** Photographs:
WELSH WAR MEMORIALS
specially photographed for the book
by Peter Jones
Top left: Mountain Ash
Top right: Pen-y-groes
Centre right: Corwen
Bottom right: Gates at Tredegar
and Field of Remembrance, Cardiff

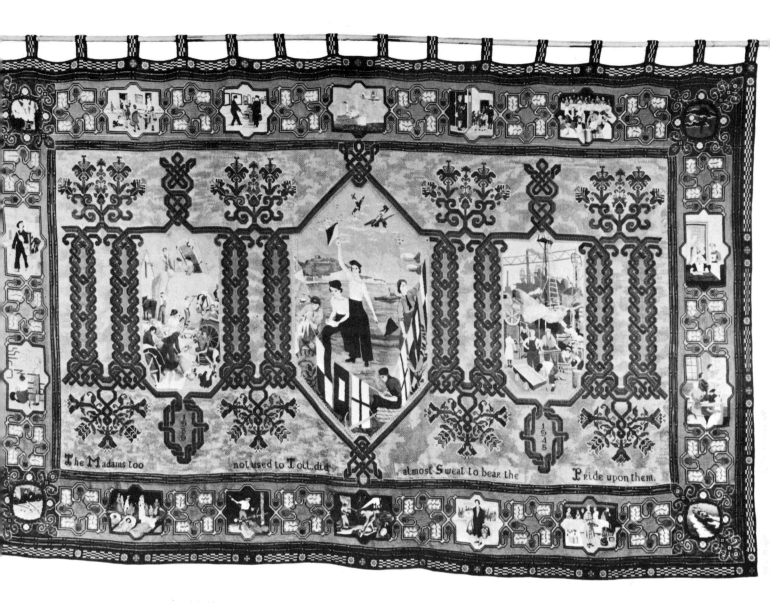

**86** Embroidery:
WOMEN'S WORK IN WARTIME
by members of the Women's Institutes
(Imperial War Museum, presented by
the National Federation of Women's
Institutes 1955)

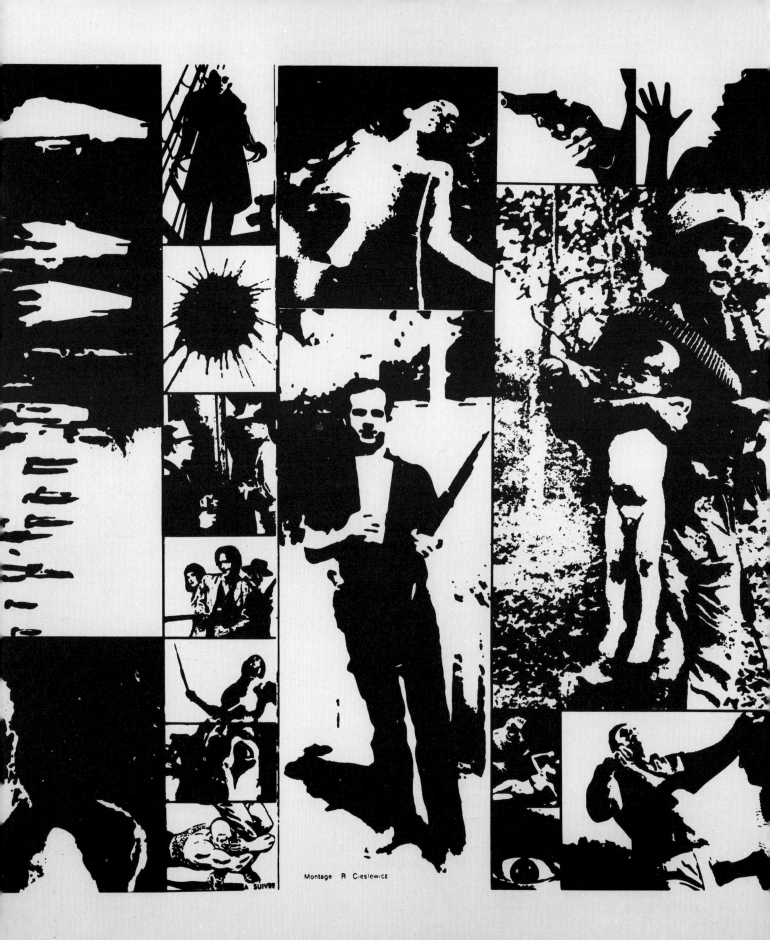

Montage R. Cieslewicz

# EXPRESSIONISM

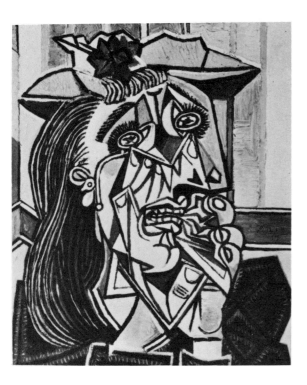

**87** Left
Detail of montage:
from OPUS INTERNATIONAL NO 7
by R Cieslewicz
(Opus International)

**88** Above
Painting:
WOMAN IN TEARS
by Picasso
(Pallas Gallery Reproduction)

The difference between Romanticism and Expressionism is at first sight a rather subtle one. Both use exaggeration and distortion in order to gain a response; both ask for the total involvement of the spectator.

**But Expressionism is completely lacking in the element of glamour that infuses Romanticism; it is raw and wounding. In terms of war, it is either pacifist or despairing: a cry of anger and pain. It is also, like Classicism, a world view. Although Expressionism's stylistic clichés are often used in propaganda its real flavour can only be found when there is a fusion between the imaginative world of the artist and the desolations of real life.**

Today, when used for political purposes, Expressionism is forced to new extremes of violence by the violent character of news reporting discussed under the heading of Realism. It often works by using factual images but arranged in such a way as to bring out their inhumanity, or at least the inhumanity of the system that produced them. It is Expressionist imagery which infuses satire and gives it the power to hurt and disgust. Obscenity of every kind is one of its basic tools.

So Expressionism is not only an attitude for great artists like Goya and Georges Rouault who, in their different ways, assaulted the conditions of their time by means of the spectres that stalked their imaginations. It is also that kind of black comedy which is mordantly applicable to hollow patriotism and jingoistic profiteering, and which the twentieth century has made peculiarly its own. After the cataclysm of the first world war, disillusion was cauterized by some of the bitterest humour ever produced. Expressionist comedy continues to berate and attack the age-old weaknesses of the human race; a goon show

89 Above
Film still:
from STALAG 17 with William Holden
Billy Wilder
(National Film Archive)

90 Opposite
Drawing:
FIT FOR ACTIVE SERVICE
by George Grosz
1916–17
(Museum of Modern Art, New York,
A Conger Goodyear Fund)

version of the Ten Commandments, it has the terrible
cutting edge of true despair.

Take this example from Joseph Heller's macabrely funny
anti-war novel *Catch-22*. Captain Yossarian is talking
with Doc Daneeka, the medical officer of an American
air base in Italy, about the best way of getting declared
insane so as to avoid combat duty:

"You mean there's a catch?"
"Sure there's a catch", Doc Daneeka replied. "Catch-22.

Anyone who wants to get out of combat duty isn't really crazy."
There was only one catch and that was Catch-22, which specified that a
concern for one's own safety in the face of dangers that were real and
immediate was the process of a rational mind. Orr was crazy and could be
grounded. All he had to do was ask; and as soon as he did, he would no
longer be crazy and would have to fly more missions. Orr would be crazy
to fly more missions and sane if he didn't, but if he was sane he had to
fly them. If he flew them he was crazy and didn't have to; but if he didn't
want to he was sane and had to. Yossarian was moved very deeply by the
absolute simplicity of this clause of Catch-22 and let out a respectful whistle.

"That's some catch, that Catch-22", he observed.
"It's the best there is", Doc Daneeka agreed.

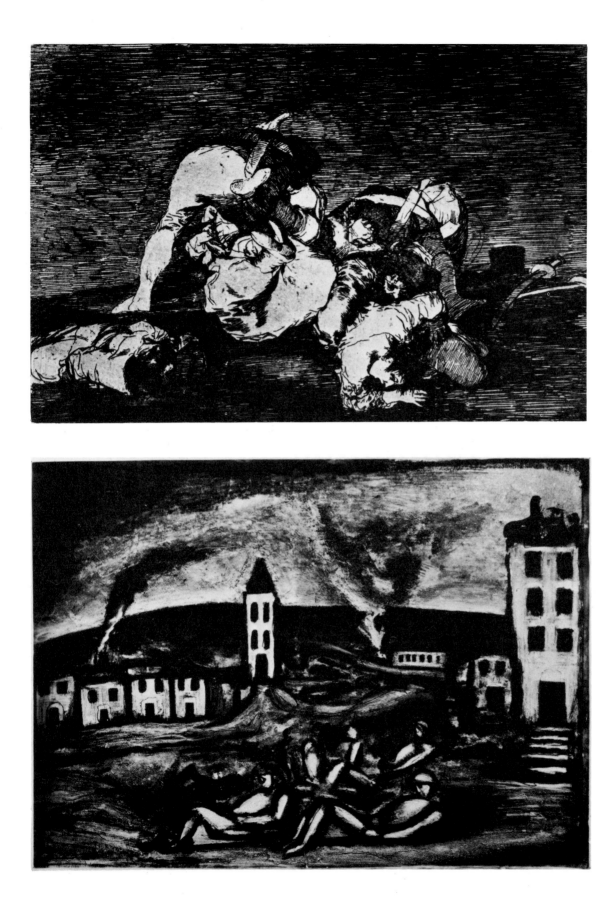

**91** Above left
Etching:
from THE DISASTERS OF WAR
by Goya
(British Museum)

**92** Below left
Etching:
MY SWEET HOMELAND, WHAT
HAS BECOME OF YOU
by Georges Rouault
from the *Miserère*
(City Art Gallery and Museum, Birmingham)

**93** Below
Detail of etching:
from THE DISASTERS OF WAR
by Goya
(British Museum)

**94** Above right
Woodcut:
from ORFEUS OG EURYDIKE PART I
by Palle Nielsen
(Hanz Reitzel)

**95** Below right
Painting:
BELSEN, APRIL 1945
by Doris Zinkeisen
(Imperial War Museum)

96 Right
Cartoon:
ANY ORDERS TO-DAY SIRE?
by Will Dyson
from *War Cartoons by Will Dyson*
First World War
(Imperial War Museum/Hodder & Stoughton)

97 Below
Painting:
LA GUERRE
by Henri Rousseau
(Musées Nationaux)

98 Opposite
Poster:
DIE HEIMAT IST IN GEFAHR!
by Hächez
Anti-Bolshevik poster
First World War period
(Imperial War Museum)

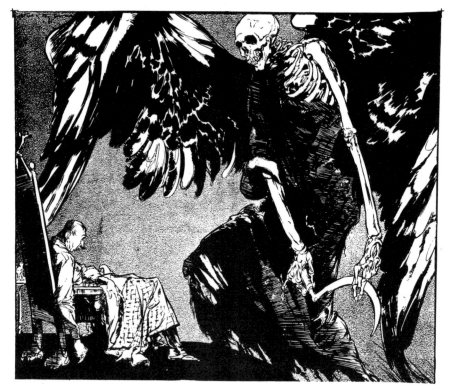

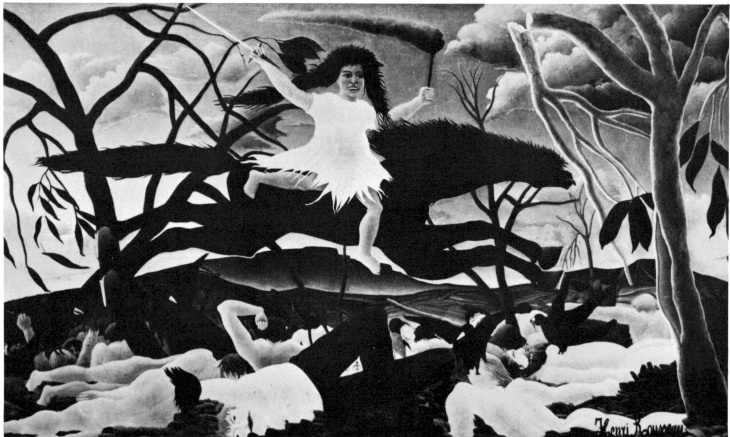

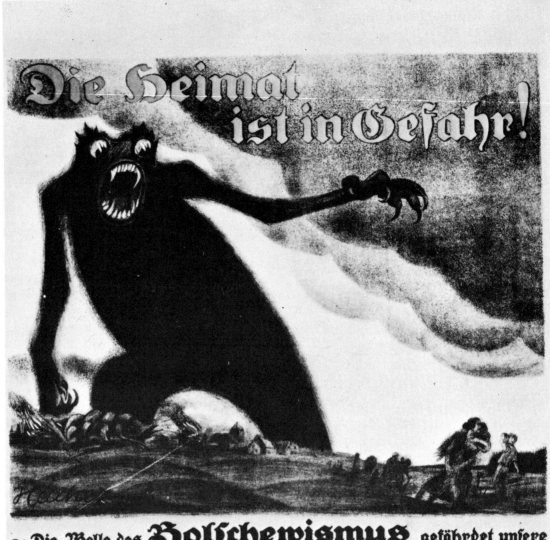

~ Die Welle des **Bolschewismus** gefährdet unsere Grenzen; im eigenen Lande regen sich bolschewistische Kräfte der Zersetzung die unser Land wirtschaftlicher Vernichtung auszusetzen drohen. **Polnische Verbände** brechen in alte deutsche Lande ein und dringen nach Westen vor.

# Große Mittel sind nötig!

## Helft sofort!     Eile tut not!

Sämtliche Depositenkassen und Zweigniederlassungen der berliner Großbanken find bereit, Beiträge unter dem Stichwort: „Osthilfe" anzunehmen.

Die Reichsregierung     Freiwillige Wirtschaftshilfe für den Ostschutz (Osthilfe) E.V.     Die Preußische Regierung

**Noske**     Hauptgeschäftsstelle: Berlin W. 9 Köthenerstr. 44² (9-3)     **Hirsch**

**Vollbehr**

Paul Grasnick, Chromo-Kunstdruck, Berlin O.27

**99** Film still:
from THE GOOD SOLDIER SCHWEIK
by Jiri Trnka
(National Film Archive)

**100** Ceramic:
SOLDIER IN GASMASK SOUVENIR
(Imperial War Museum: photograph by
Brian Gardiner)

**101** Gasmask:
'MICKEY MOUSE' TYPE
Second World War
(Imperial War Museum)

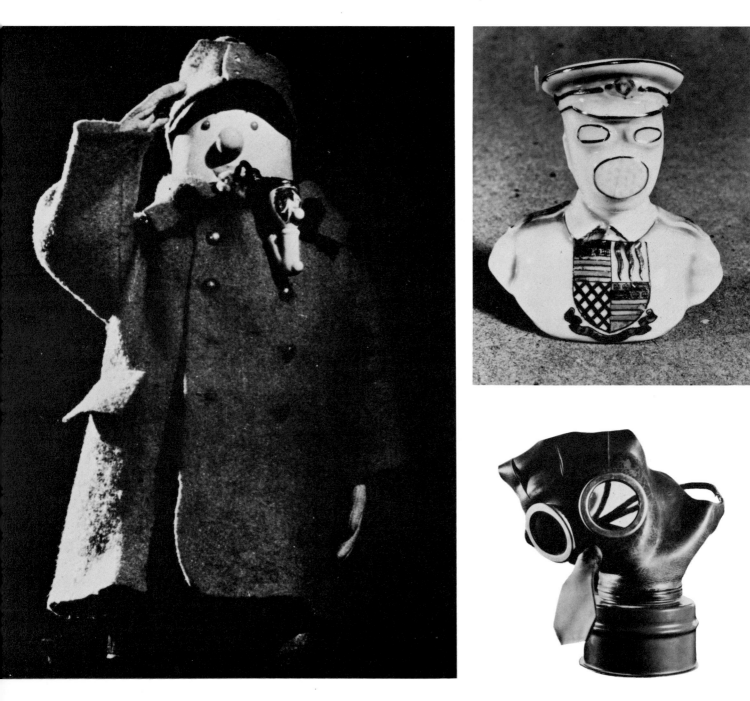

# ESCAPISM

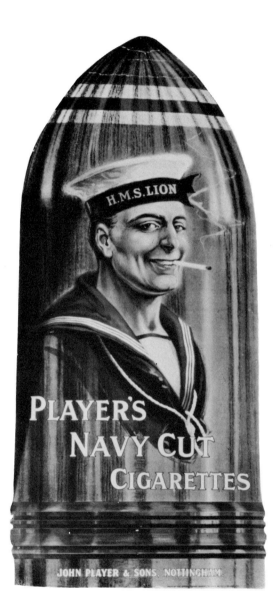

**102** Poster card:
SAILOR ON SHELL
First World War
(Imperial War Museum: photograph by Brian Gardiner)

Escapist style is not easy to characterize. In some ways it is like Romanticism, but while Romanticism works from within the real ingredients of warfare, Escapism neutralizes savage experience by making from it a pretty and decorative dream.

**Take the figure of the soldier. As we have seen already, he can appear as a hero or a villain; a chivalrous knight, a monstrous murderer or an injured dupe. Realistically, he is a complex combination of many contradictory qualities and feelings, playing out a role that still seems to be at the core of human civilization. But all this expression is based at some point, however remote, on an appreciation of what a soldier is for. In Escapism such a link is avoided. The soldier becomes simply a decorative object, an adult toy with a pop gun that shoots candy floss.**

It is easy to understand the direct Escapism of wartime, when music and spectacle naturally tend towards luxury and nostalgia, often using the trappings and detail of military situations. But the same kind of glitter exists in peacetime too, and seems to be as fundamentally necessary a reaction to the modern world's anxieties as Romanticism is to its dullness. The menace of the Nazis in that masterpiece of Escapism *The Sound of Music* is about as gripping and sinister as a plastic daffodil, but it moves the plot along and allows the reek of twentieth-century violence to be drenched in the powerful deodorant of sentimentality.

Escapism is not always simple, nor is its meaning always obvious. It is clear, for example, that there is something essentially Escapist about a pretty girl in a sailor suit singing *All The Nice Girls Love A Sailor*. But this is a

**103** Below
Film still:
from OH! WHAT A LOVELY WAR
Richard Attenborough
(Paramount Pictures Ltd)

**104** Opposite
Film still:
from SOUTH PACIFIC
Joshua Logan
(National Film Archive)

tremendously complex image. First, there is the pantomime illusion of swopping round the sexes. Second, sailors are supposed to be *par excellence* lecherous. Third, the uniform is inescapably connected with war. As a mixture, the elements just don't add up, but the female impersonation of military gentlemen seems to be as old as music hall and could easily be much older. Undoubtedly there are psychological explanations that make good sense of the fascination of this male/female, aggressive/submissive image, but they are rather heavyweight for such an unpretentious piece of nonsense. It seems more likely that it is precisely the basic contradictions in the situation that make it effective Escapism – absurdity is being used for the same purpose as sentimentality in *The Sound of Music*.

**Actually, in relation to war, Escapism is always poised on a knife edge. Its images are in constant danger of being kidnapped; its lightheartedness of being tricked by context. In Richard Attenborough's splendid film version of *Oh! What A Lovely War* the trap is sprung constantly. In the music hall scene, young men are recruited by girls singing a pretty and seductive song – the men escape into their waiting arms and out onto the battlefields to die.**

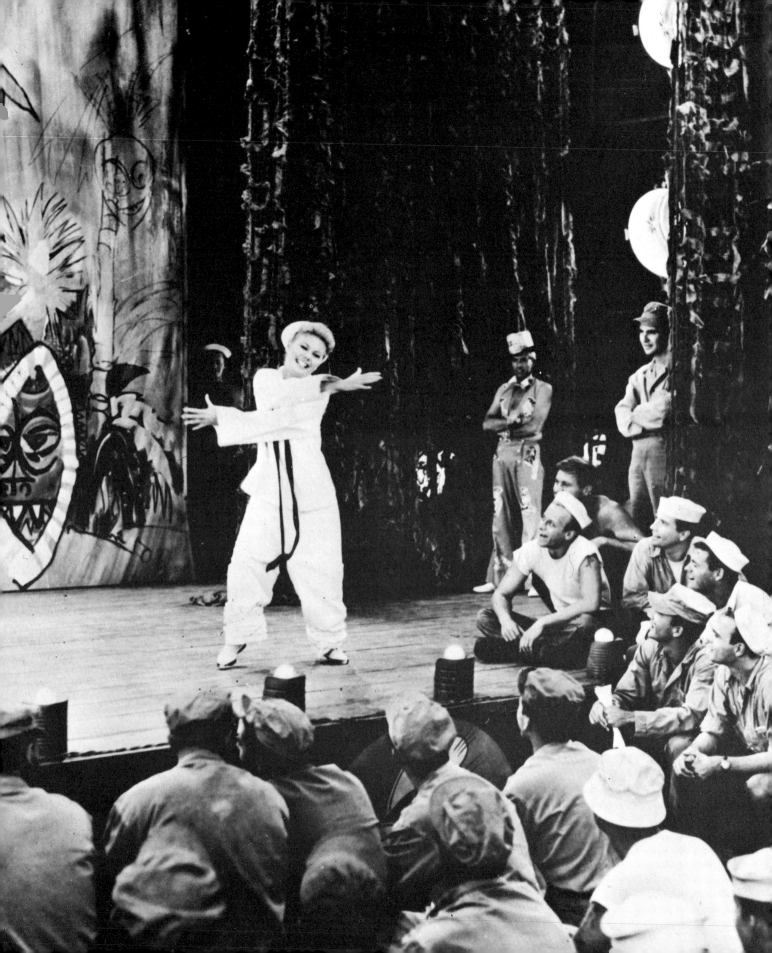

**105** Photograph:
FRUIT PICKER PIN UP
First World War
(Imperial War Museum)

**106** Book:
THE GOLLIWOGG (SIC) IN WAR
1899
(Museum of Childhood, Edinburgh:
photograph by Brian Gardiner)

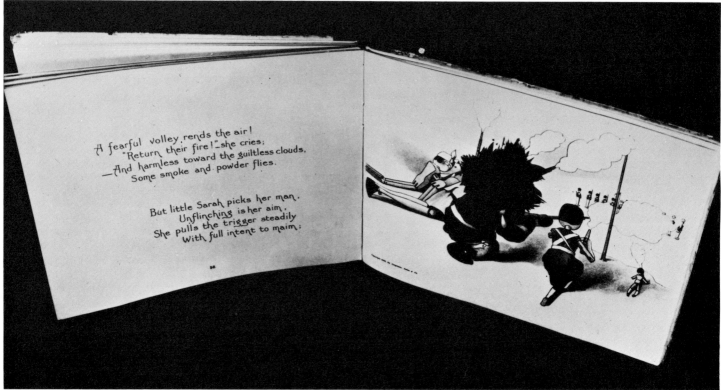

A fearful volley rends the air!
"Return their fire!" she cries;
—And harmless toward the guiltless clouds,
Some smoke and powder flies.

But little Sarah picks her man,
Unflinching is her aim,
She pulls the trigger steadily
With full intent to maim:

**107** Below
Photograph:
VERA LYNN – THE FORCES SWEETHEART
(Radio Times Hulton Picture Library)

**108** Top right
Painting:
THE BARMAID AT THE RED LION
by Edward Ardizzone
Second World War
(Imperial War Museum)

**109** Bottom right
Detail of illustration:
showing the WHITE KNIGHT'S EQUIPMENT
by John Tenniel
from *Through the Looking Glass*
(Macmillan & Co Ltd)

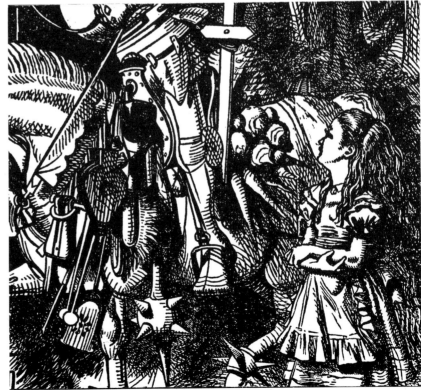

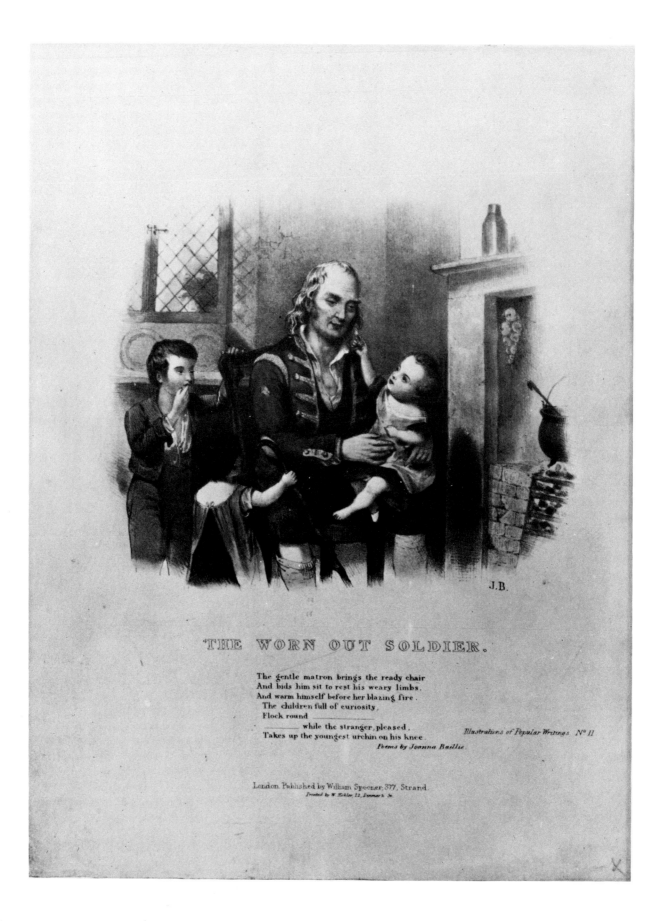

THE WORN OUT SOLDIER.

The gentle matron brings the ready chair
And bids him sit to rest his weary limbs.
And warm himself before her blazing fire.
 The children full of curiosity,
 Flock round —————————————
 ————— while the stranger, pleased,
 Takes up the youngest urchin on his knee.

*Illustrations of Popular Writings. N.º II*

*Poems by Joanna Baillie.*

London. Published by William Spooner, 377, Strand.
Printed by W. Kohler, 23, Denmark St.

# CONCLUSION

**110** Lithograph:
THE WORN OUT SOLDIER
published by William Spooner
(Mansell Collection)

**111** Cartoon:
FIRST AND SECOND CONTEMPTIBLES
DISCUSSING DEVASTATION
by Fougasse
First World War
(*Punch*)

*First Contemptible.* "D' YOU REMEMBER HALTING
HERE ON THE RETREAT, GEORGE?"
*Second ditto.* "CAN'T CALL IT TO MIND, SOMEHOW.
WAS IT THAT LITTLE VILLAGE IN THE WOOD
THERE DOWN BY THE RIVER, OR WAS IT THAT
PLACE WITH THE CATHEDRAL AND ALL
THEM FACTORIES?"

The material about War in this book was chosen to
demonstrate how art, in the broadest sense of the word, is
enmeshed in the aims of society. It shows something of how
art reflects and makes coherent the relationship between the
experience of the individual and the collective, interpretative,
body of work called culture. It shows how art is part of the
mechanism of life as well as a means of commenting on it.

The book does not have a single clear cut message about war,
but inevitably it reflects war's frightening ubiquity, its
centuries old imperative. If art is deeply enmeshed in
society, so evidently is war. The illustrations almost seem
to say that conflict is fundamental to the actual existence
of any kind of social structure, yet they also show the ugly
futility of destruction with the clarity of a fierce sermon.

These stark alternatives and the density of the emotions
involved are too complex to be resolved. A bloodstained
national flag can still be a grand emblem of courage and
glory or a satirical symbol of senseless waste and destruction.
In this situation art speaks with a parallel variety of voices.
But it shows particularly clearly the seduction of war and
how this operates powerfully on the imagination. And art
itself contributes to the seduction by helping to give form to
the myth which impels men on until remembered experience
– and its documentation – becomes irrelevant.

Fougasse

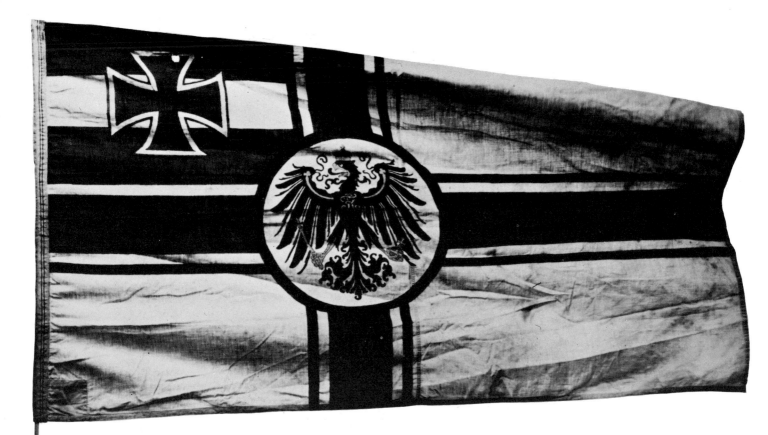

Siegfried Sassoon, the first world war poet, wrote:

In fifty years, when peace outshines
Remembrance of the battle lines,
Adventurous lads will sigh and cast
Proud looks upon the plundered past.
On summer morn or winter's night
Their hearts will kindle for the fight,
Reading a snatch of soldier-song,
Savage and jaunty, fierce and strong.
And through the angry marching rhymes
Of blind regret and haggard mirth,
They'll envy us the dazzling times
When sacrifice absolved our earth.

Some ancient man with silver locks
Will lift his weary face to say:
'War was a fiend who stopped our clocks
Although we met him grim and gay'.
And then he'll speak of Haig's last drive,
Marvelling that any came alive
Out of the shambles that men built
And smashed, to cleanse the world of guilt.
But the boys, with grin and sidelong glance
Will think, 'Poor grandad's day is gone'.
And dream of lads who fought in France
And lived in time to share the fun.

**112** Flag:
GERMAN NAVAL COMMODORE FLAG
(Imperial War Museum: photograph by
Julian Sheppard)

**113** Painting:
AN EPISODE IN THE
BATTLE OF SAILUM VUM
(CHIN HILLS, BURMA) –
SUBEDAR RAM SARUP
SINGH WINNING THE V C
artist unknown
(Imperial War Museum:
photograph by Brian
Gardiner)

**114** Photograph:
SCENE IN THE YEMEN
DESERT
by Lord Kilbracken
(Camera Press, London)

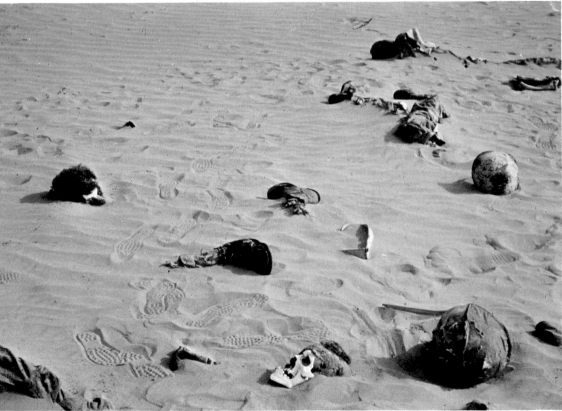

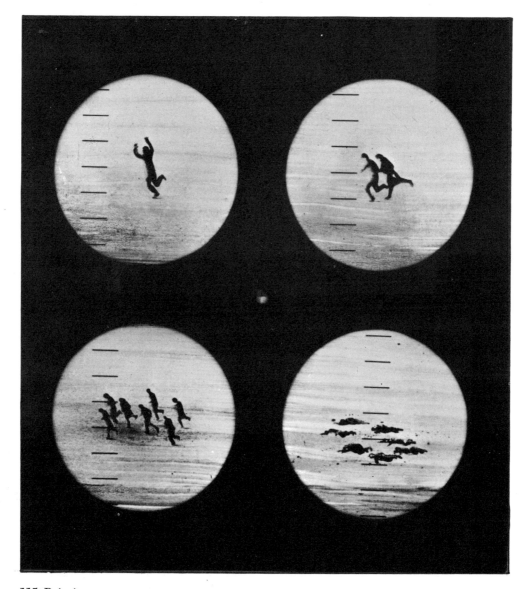

**115** Painting:
UNO DOS SIETE, SIETE
by Juan Genotes
(Marlborough Fine Art (London) Ltd)

**Inside back cover**
Detail of painting:
THE TRIUMPH OF DEATH
by Pieter Bruegel
(Prado, Madrid)

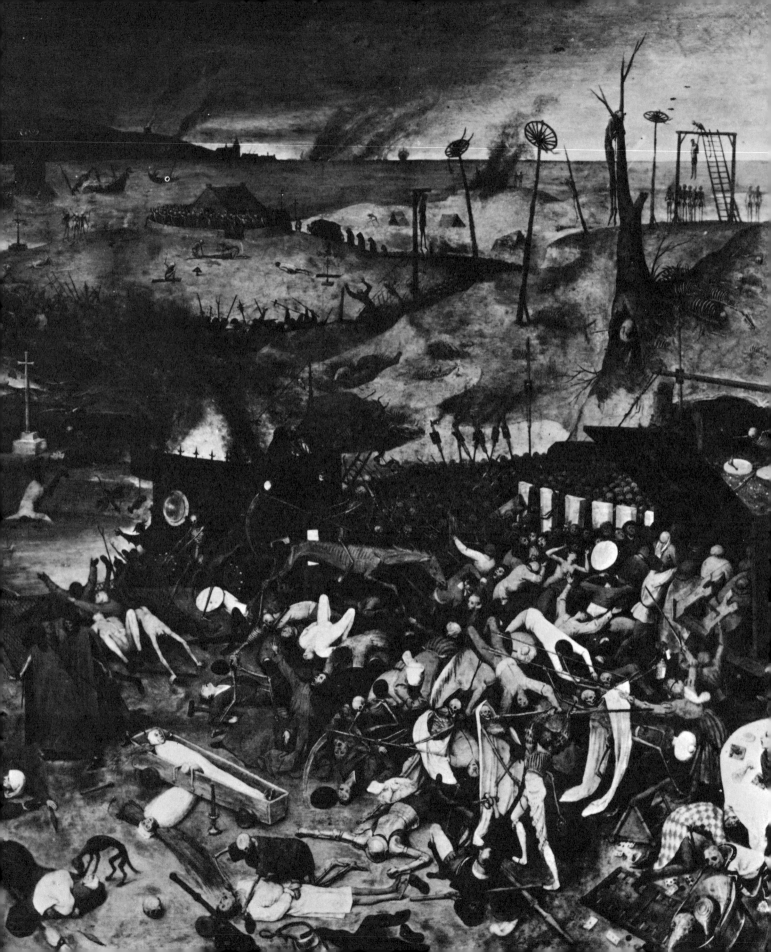

DATE DUE